IMAGES
of America
CHICO

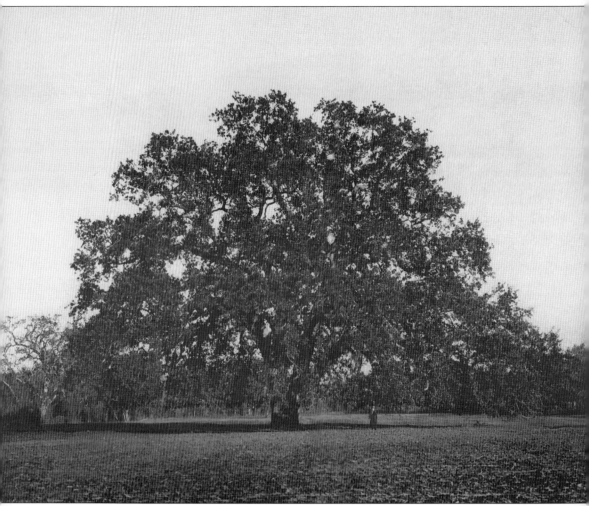

John Bidwell named the massive oak tree in Bidwell Park after British botanist Sir Joseph Hooker, following Hooker's visit to Chico in 1877. Hooker inspected the tree and declared it to be nearly 2,000 years old. When the tree toppled under its own weight in May 1977, however, upon closer inspection it turned out to be two trees and only about 500 to 600 years old. Still, the tree's majestic size and bearing were its two main attributes, and generations of Chicoans and visitors climbed its branches and marveled at its beauty.

Edward Booth, John Nopel, Keith Johnson, and Darcy Davis

Copyright © 2005 by Edward Booth, John Nopel, Keith Johnson, and Darcy Davis

ISBN 978-0-7385-3057-4

Published by Arcadia Publishing
Charleston SC, Chicago IL, Portsmouth NH, San Francisco CA

Printed in the United States of America

Library of Congress Catalog Card Number: 2005929617

For all general information contact Arcadia Publishing at:
Telephone 843-853-2070
Fax 843-853-0044
E-mail sales@arcadiapublishing.com
For customer service and orders:
Toll-Free 1-888-313-2665

Visit us on the Internet at www.arcadiapublishing.com

Contents

Acknowledgments		6
Introduction		7
1.	Broadway	9
2.	Main Street	29
3.	The Bidwells	49
4.	Academia	55
5.	The Esplanade, Chico's Grand Boulevard	71
6.	Around and About	79
7.	You Can't Get There from Here	111

Acknowledgments

Several people contributed immensely in helping me make this book a reality. First, and certainly foremost, is John Nopel—Chico's authority on the history of the town in particular and Butte County in general. Sitting with John as he explained the subjects and history in his photographs was like sitting in a classroom, listening to the master effortlessly talk about what would otherwise fade into the mists of time.

Keith Johnson of the Butte County Historical Society has been tremendously helpful in finding photographs representative of Chico's past. I knew some of the photographs existed; others I did not. They're all sensational, and Keith knew where to find them in the society's massive files.

Bill Jones at Chico State University's Special Collections in the Meriam Library helped me locate historical photographs that were good candidates for cover shots.

Valerie Bivens, who runs the shop for Michael Agliolo's Photo Restoration, did a superb job of scanning old photographs and putting them on disks. She also corrected little dings in the images here and there, making them look better despite their years.

Darcy Davis shot the contemporary photographs of Chico, always exceeding expectations and doing it cheerfully. I knew she was an excellent photographer, but when I saw her finished products, I was always impressed that she had raised the standard yet again. Her husband, Dan, offered critiques and advice, helping to improve the photographs even more.

My dear friend Jake Early inspired me on this project, thanks to the success of his Chico screenprints. He assured me that people would find any book about Chico's history to be a grand slam.

Teri Davis scanned quite a few photographs, too, doing so despite her busy schedule. Steve Schoonover, Laura Urseny, and Ari Cohn of the *Chico Enterprise-Record* fed me morsels of information that helped make my research complete. I also got information from Joseph McGie's outstanding two-volume book *History of Butte County*.

My mother, Bobbie Jean Booth, has always been interested in Chico's history, and gave me encouragement and a few facts here and there. I dedicate my research to my father, Eddie Booth, who died in 1994. He was the ideal newspaperman and had a thirst for knowledge that I've inherited.

And finally, my beautiful bride, Shanna, has given me a huge amount of support, especially at times when it would have been easier just to give up. She wouldn't let me. I'm glad, and I give her my thanks and love.

Thank you all.

—Edward V. Booth

INTRODUCTION

Ask just about any California resident for examples of what a "nice town" should be, and Chico is likely to be one of the answers. This is no accident. From the earliest days of Rancho del Arroyo Chico in the 1840s, through 1860, when John Bidwell laid out the core of the town in a grid pattern, through 1887, when the state placed a college here, until the present, Chico has long been regarded as a truly nice place.

It has served tens of thousands of people in many ways: as a starting point for men seeking their fortunes in gold in the mid-1850s, a commercial center for ranchers and farmers, and a place of higher education. It was a base for military aviators in the 1940s and a resting point for travelers on U.S. Highway 99E, before Interstate 5 was built. Over the past 20 years, it has been, unfortunately, a place for out-of-towners to carouse during drunken riots involving students.

Mostly it has been a pleasant place in which to live and grow up for many people like me. Some people stay here their entire lives. Some leave, believing Chico to be too small, but come back when other towns and cities fail to satisfy them. Some leave and don't come back, but always hold it dear to their hearts.

Ever since John Bidwell laid out its central streets nearly 15 decades ago, then built his grand mansion for his bride, Annie, in 1868, Chico has been a town with many landmarks. You'll see many of them in this book. Thanks to the impressive photographic collection of Chico's unofficial historian, John Nopel, you can get a glimpse into its past. See how the town has grown and changed—or not changed, as some of the contemporary photographs will prove.

Chico has grown—some say too quickly and too much—but that's to be expected in a place that's so appealing. The question is, will its charm be squashed by this growth, as progress leaves a permanent mark? Many of Chico's old buildings were demolished or dramatically altered in the name of "progress." Those remaining have been revitalized, and they are the basis of the town's core.

Turn these pages and enjoy side-by-side comparisons of Chico's landmark buildings. I'm sure you'll find it to be a trip through time you'll love to take again and again.

One

BROADWAY

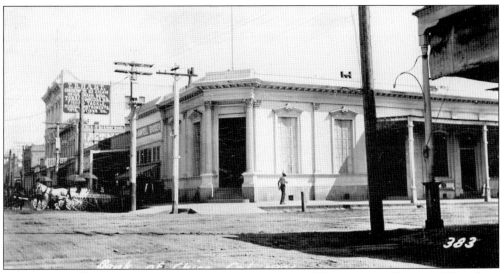

The Bank of Chico was located on the southwest corner of West Second Street and Broadway in 1906. The corner has been home to various financial institutions since the 1870s, including the current occupant, Washington Mutual. Clearly visible in the background is the Odd Fellows Hall.

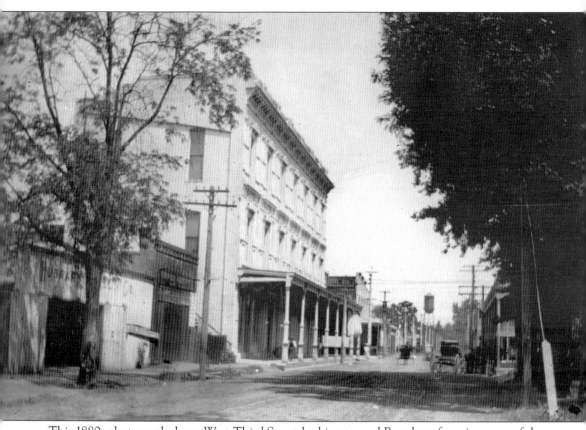

This 1880s photograph shows West Third Street looking toward Broadway from just west of the Odd Fellows Building. Lee Pharmacy was the ground-floor tenant for only three or four years at the time. Note the horse-drawn buggy about to cross Broadway. Where a lush tree stands at right in this image, a City of Chico parking structure looms today. Approximate dating of this photograph comes from the fact that the Phoenix Building, known as the J.G. Noonan Block when it was built, went up in 1889 on the south side of Third Street and is not seen here. (Courtesy of John Nopel.)

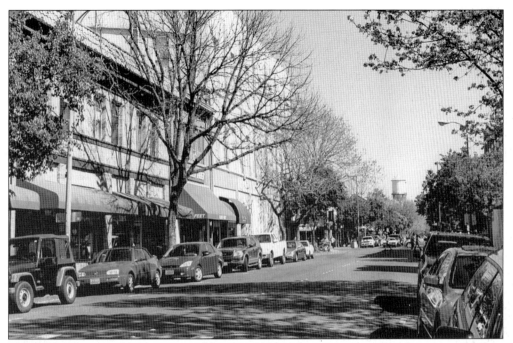

The Odd Fellows Building is pictured here in 2005 without its ornate facade, removed during "modernization" in the 1940s. Today the structure houses the Ballroom on Broadway and Starbucks Coffee, the latter occupying the space where Lee Pharmacy was until 1996. The Odd Fellows built an annex to their facility, left, which also provides retail space on the ground floor with apartments and offices above. At right, on the corner of Third and Broadway, is the Phoenix Building. It was called Toad Hall until it was gutted by fire in 1973. Truly emerging from the ashes, the building now houses numerous shops and restaurants.

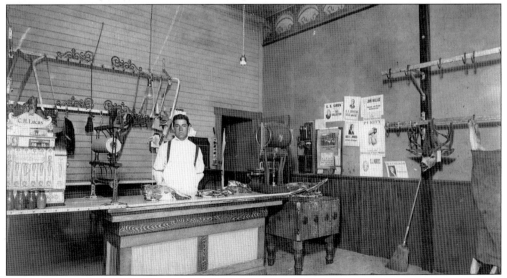

Butcher Thomas J. Lucas posed for this 1902 photograph inside the Chico Meat Market at Third and Broadway. Charles Lucas, his son, later owned the store, which occupied the same site in the Phoenix Building that Jon and Bon's Yogurt Shoppe occupies today. (Courtesy of Butte County Historical Society.)

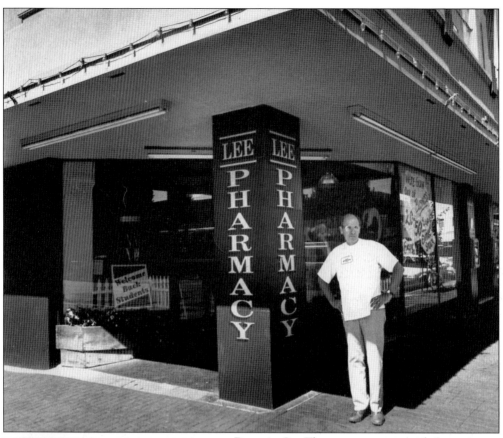

Druggist Stu Thompson poses outside Lee Pharmacy shortly before it closed in 1996. Thompson was the final owner of the store, which Wesley Lee opened on the site in 1857. When the Odd Fellows put up the building in 1884, the pharmacy stayed at that address and in the 20th century was affiliated with the Rexall brand. Patrons remember the orange-and-blue Rexall sign that hung outside the store for decades. (Courtesy of John Nopel.)

The building now contains offices for local developer Eric Hart, as well as the Ballroom on Broadway, a facility available for social gatherings. Starbucks Coffee occupies the space where Lee Pharmacy conducted business for so many years.

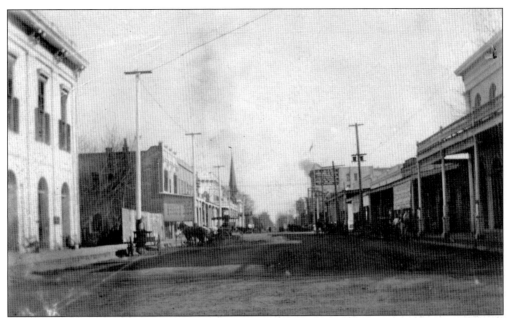

This serene c. 1900 view of Broadway looks south from West First Street. The Masonic Building is visible at far left, and houses what is now Collier Hardware on the ground floor, as well as the Blue Room Theater upstairs. The *Record*, Chico's afternoon paper for nearly seven decades until it merged with the *Chico Enterprise* in 1946, was published in the two-story building with awning at center left in this photograph. (Courtesy of John Nopel.)

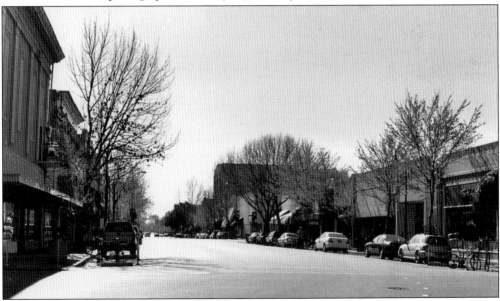

Today Collier Hardware occupies the ground floor of the Masonic Building, and space just to the south of it has been filled by small restaurants and stores, with professional offices above. Broadway, meanwhile, hums with southbound traffic, most of which came from the Esplanade. Chico's downtown traffic signals, as well as most of those on south Esplanade, are on timers. They regulate vehicles at approximately 25 miles per hour, allowing traffic to run smoothly and efficiently through what would otherwise be a heavily congested area.

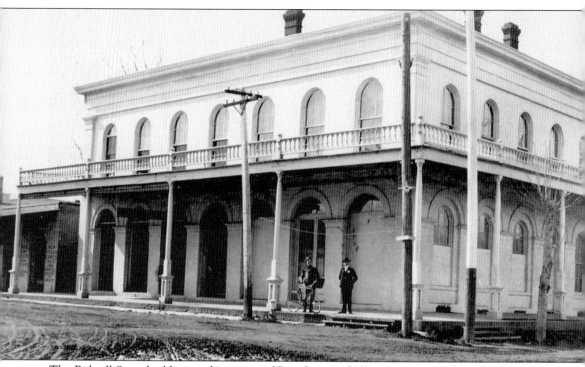

The Bidwell Store building at the corner of Broadway and West First Street, the oldest existing structure in Chico, was completed in 1861 shortly after John Bidwell laid out the town's grid of streets. The building has housed numerous retail and professional businesses through the years, starting with Bidwell's general store, before Chico was much of a town. (Courtesy of John Nopel.)

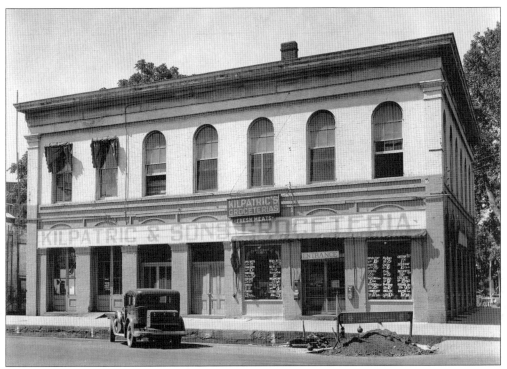

Kilpatric and Sons Groceteria is pictured at the same corner in 1932. Here the building features two stories, but the upper floor was removed at some point in the early 1950s due to the fear of collapse from an earthquake. (Courtesy of Butte County Historical Society.)

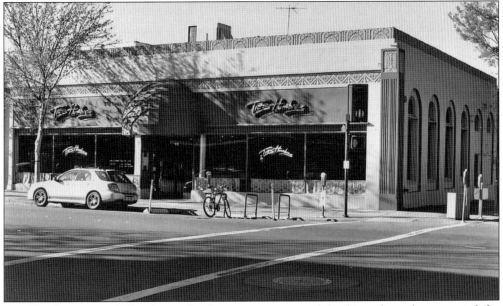

Tres Hombres, one of Chico's popular downtown eating and drinking places, has occupied the corner since 1987. The facade has changed considerably, losing its top story and veranda, and gaining an art deco front. Patrons can dine or drink at the window seats and watch pedestrian and vehicular traffic go by.

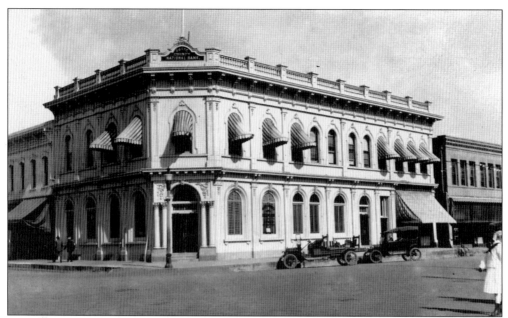

An early institution in the community, the Bank of Butte County was a familiar landmark at the southeast corner of West Second Street and Broadway. This c. 1920 shot demonstrates how the awnings were—and are—crucial to help provide protection from the punishing summertime heat Chico endures. The building was demolished about a decade later to make way for Bank of America's new facility, completed in 1931. Banks had occupied the corner since the 1870s. (Courtesy of John Nopel.)

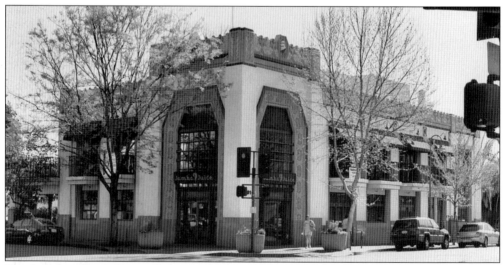

First Interstate Bank departed in 1996 after its merger with Wells Fargo Bank. The old building was boarded up and sat vacant until the following year, when San Francisco–based Chevy's converted it into restaurant space. Chevy's Fresh Mex opened in May 1998, following a massive reconfiguration that installed a second floor while retaining most of the substance of the original facility. Chevy's closed in 2002, however, due to the company's inability to recover its costs of renovation. Jamba Juice occupies part of the ground floor today and does a brisk business, while the rest of the building remains idle.

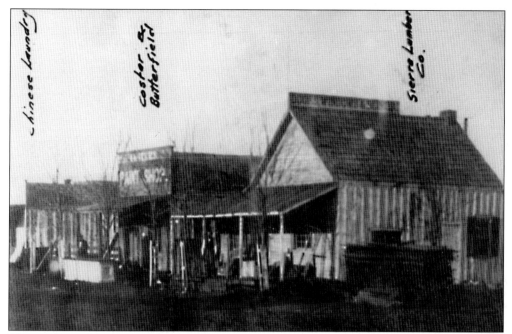

This is the earliest-known photograph of downtown Chico, taken in 1866. At the time, the east side of Broadway between West Third and Fourth Streets featured a Chinese laundry (left), general merchants Costar and Butterfield (center), and the Sierra Lumber Company. (Courtesy of John Nopel.)

Dirt streets and wooden sidewalks disappeared in the 1920s, and Chico retains none of its Wild West appearance of the early days. The only structures on the east side of Broadway between Third and Fourth Streets are World Savings (left), an antique store, and the Waterland-Breslauer Building. A parking lot is also part of the mix today.

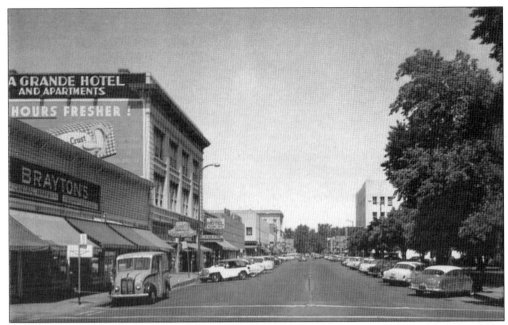

Here is Broadway, looking south from West Fifth Street in the mid-1950s. City Plaza is at right. The La Grande Hotel was largely an apartment complex by this time, and Brayton's was a large purveyor of stationery, greeting cards, gift-wrapping paper, and so forth. It was demolished in 1965 to make way for Taco Bell, which remains today. Broadway was a busy street, but not nearly as busy as Main Street, which also served as U.S. Highway 99E until the mid-1960s. (Courtesy of Butte County Historical Society.)

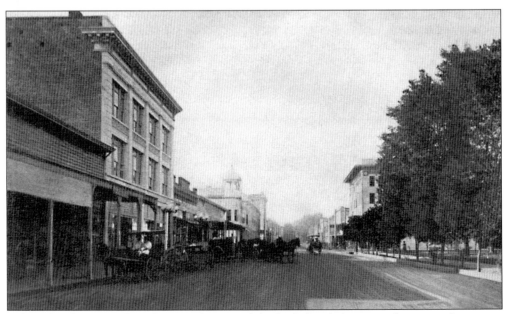

When this shot was taken about 1915, automobiles had already begun to dominate the streets, with horse-drawn buggies on a sharp decline. Paved streets made travel more comfortable as well. Broadway was paved in 1921. (Courtesy of John Nopel.)

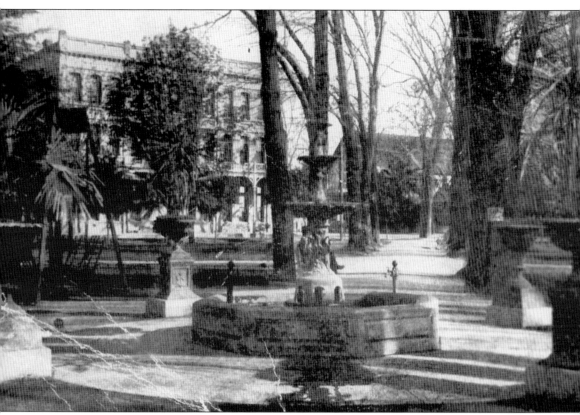

This c. 1910 photograph of City Plaza looks toward Fourth and Main Streets. The fountain and other ornate monuments have long since been removed. The fountain was taken out in the 1950s in favor of a smaller one for drinking. By the time this shot was taken, the elms John Bidwell planted in 1874 were nearly 40 years old. In the background is the Park Hotel, which survived into the 1960s. (Courtesy of Butte County Historical Society.)

Saloons and small restaurants have been the main tenants at 134 Broadway since at least the 1890s, when patrons and employees posed for this photograph in front of the Western Saloon. (Courtesy of Butte County Historical Society.)

This c. 1905 photograph was taken in the same location, but by then the establishment had become the Cabinet Saloon. A variety of businesses occupied the site over the years, mostly offering food or beverage, though a video-game arcade called The Force held the spot in the early 1980s. (Courtesy of Butte County Historical Society.)

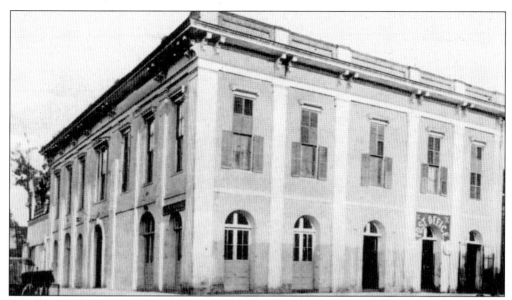

The Chico Masonic Lodge constructed this building at the corner of West First Street and Broadway in 1871, with the lodge occupying the upper floor. The ground floor served, among other things, as Chico's fourth post office (right). At left is the still-operating and venerable Collier Hardware. (Courtesy of John Nopel.)

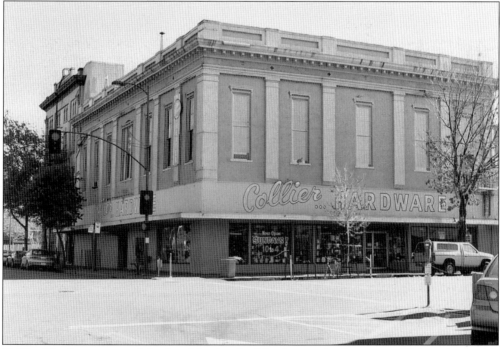

Collier Hardware, one of the last "destination" businesses in downtown Chico, along with Shubert's Ice Cream on East Seventh Street, occupies the entire ground floor of the building today. It remains the place Chicoans visit to purchase just about everything from hard-to-find sizes in nails, bolts, and drill bits, to kitchen goods and small appliances.

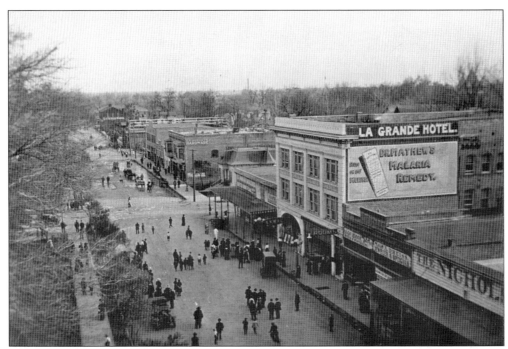

This was the view down Broadway from the top of the Waterland-Breslauer building in 1914. At far right is Nichols Hardware, with Chico Book and Stationery and the La Grande Hotel to the south. (Courtesy of John Nopel.)

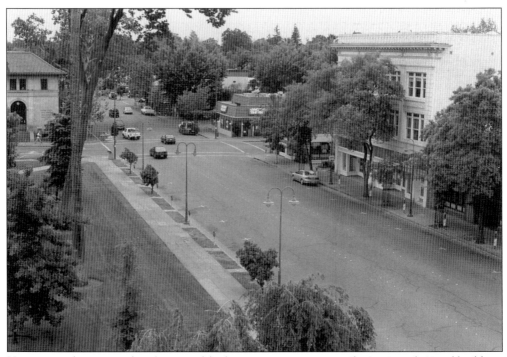

Here is a modern view taken from roughly the same vantage point. The La Grande Hotel building, finished in 1909, is still in place, though none of its neighbors remains.

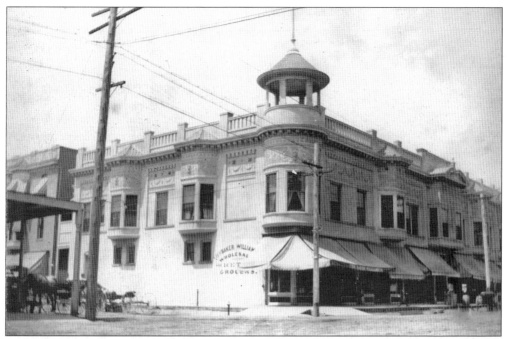

Looking stylish in the early 20th century was the Morehead Building, constructed in the 1890s with a distinctive turret and bay windows. At far left behind the Morehead is the Hotel Diamond, completed in 1904 and boasting Chico's most luxurious place to lay one's head. The Morehead, like most buildings of its type, had retail space on the ground floor and professional offices upstairs. (Courtesy of John Nopel.)

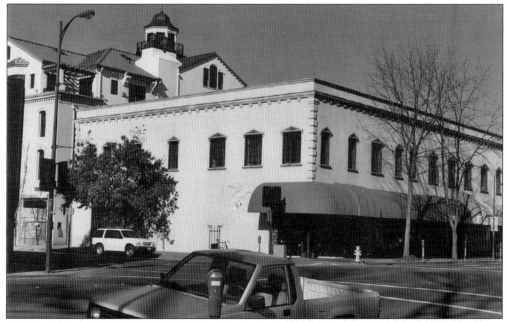

The Morehead continues to serve as an important professional and retail center in 2005, though it was modernized in the 1940s with the removal of its turret and bay windows. The nearly complete Hotel Diamond is in the background, one story taller than it was originally constructed.

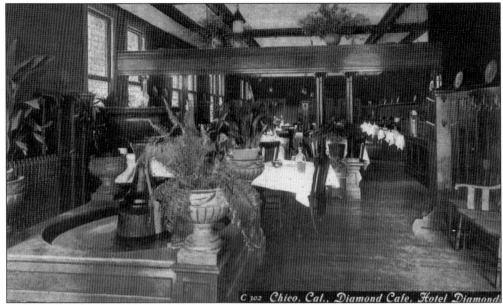

This 1909 postcard shows the interior of the Hotel Diamond's cafe on West Fourth Street, between Salem Street and Broadway. The hotel opened for business in 1904 as a truly grand and luxurious establishment, but was burned in 1916. It reopened for some years as the Travelers Hotel, designed for those seeking economical lodging, and operated into the 1950s. It was used thereafter for storage. Later it became a girls dormitory for Chico State College students in the 1960s, before it was shuttered. On the ground floor, however, clubs such as Mike and Eddie's and Delancey's remained in operation until the late 1980s, when they, too, ceased operations. Chico developer Wayne Cook renovated the building and reopened it as the Hotel Diamond on May 12, 2005. (Courtesy of Butte County Historical Society.)

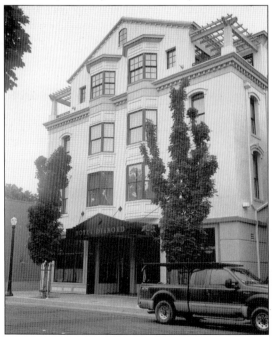

The Diamond, viewed from West Fourth Street, appears shortly after its grand reopening in 2005.

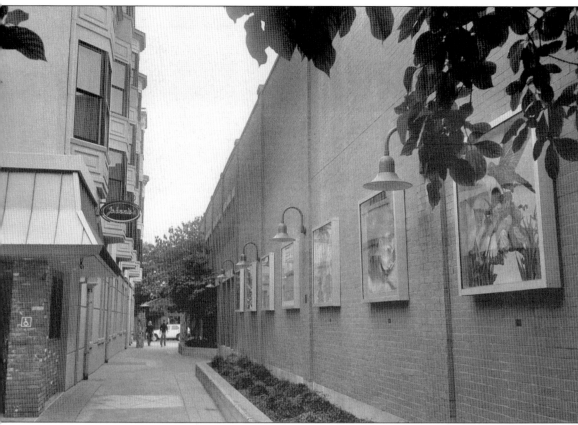

Pictured in 2004, Diamond Alley is the city-owned walkway linking Third and Fourth Streets between the parking structure and the Hotel Diamond, the Phoenix Building, and Bird in Hand. Along the wall of the parking structure are examples of entries in the Chico Open Board Art project (COBA), which allows local artists to hang their works in secure display cases for public inspection.

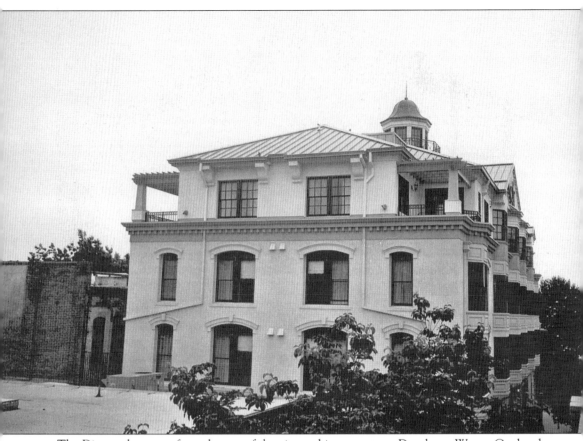

The Diamond, as seen from the top of the city parking structure. Developer Wayne Cook, who restored the building, added a fourth floor and then capped it with a cupola that is visible from most of downtown. The cupola has lights that give a gentle glow at night.

Pictured above is the Waterland-Breslauer Building on the northeast corner of West Fourth Street and Broadway, shortly after its completion in 1914. It's so new, in fact, that the ground-floor retail space is still vacant. The upper floors housed professional offices. (Courtesy of John Nopel.)

Painted pink with ornamental "columns" in the late 1990s, the Waterland-Breslauer is still home to professionals as well as radio station KZFR. The ground floor features retail establishments.

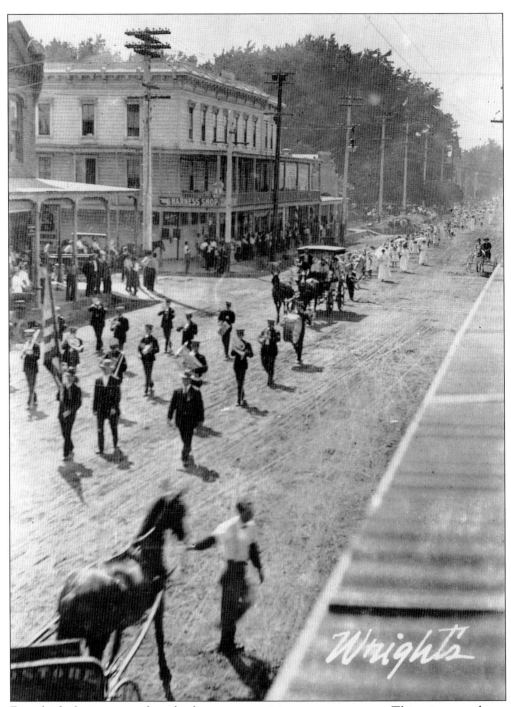

Everybody loves a parade, whether as a participant or spectator. This view south on Broadway in the late 19th century featured a brass band. The harness shop sits at the corner of West Third Street. City Plaza is plainly visible, thanks to its leafy trees. (Courtesy of John Nopel.)

Two
Main Street

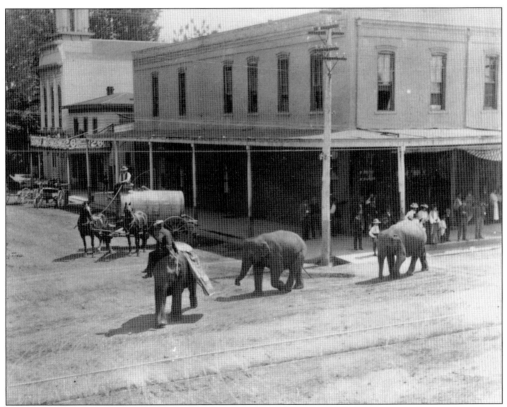

A circus parade reaches Second and Main Streets in about 1900. Circuses were always a big event in Chico. Merchants would suspend business when the trains arrived carrying the animals and performers, as parades would always draw large crowds. (Courtesy of John Nopel.)

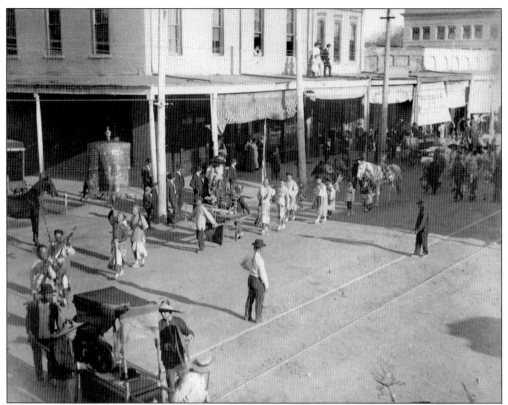

In this c. 1910 photograph, Chinese residents of Chico participate in a cultural parade crossing the intersection of Second and Main Streets. From the town's earliest days, Chico had a substantial Chinese community. Orient Street, three blocks east of Main Street, was named for the concentration of Asians in the area. (Courtesy of John Nopel.)

Chinese immigrants, who had come to California in large numbers during the gold rush, were never treated well by Caucasians in Chico, and had mostly left town by the turn of the 20th century. There's no longer a concentration of any particular ethnic group in Chico, though Chapmantown, the area south of Little Chico Creek and roughly east of Park Avenue, has the town's most diverse population.

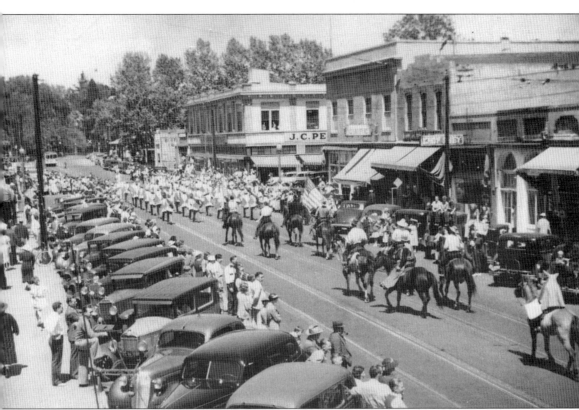

In days gone by, parked cars and spectators spilled into the street for parades. Most prominent in this mid-1940s shot of a parade on Main Street, looking north from Third Street, is J. C. Penney, located on the northeast corner of Second and Main. That was the first location of the store in Chico, where it opened in 1913 as only the second Penney's in California. Needles had the first store, but it no longer exists. Chico now has the oldest continually operating store in the state. It moved to 319 Main Street in 1950, and in 1968 it moved to the newly completed North Valley Plaza, just off Cohasset Road. The company transferred to its present location at the Chico Mall off East Twentieth Street on October 6, 1993, enjoying 104,230 square feet of floor space and the area's only escalator. (Courtesy of John Nopel.)

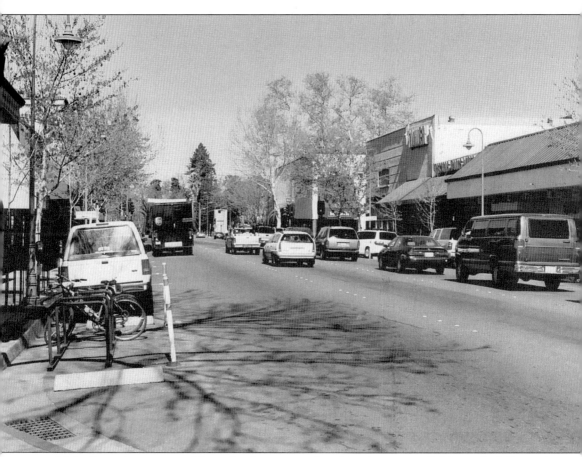

Main Street is now a northbound-only street, and parking is now parallel instead of diagonal. It's still an area loaded with stores and cafes offering a wide range of services and goods. Berkeley-based Peet's Coffee and Tea now occupies the spot where Penney's and numerous other retailers once conducted business.

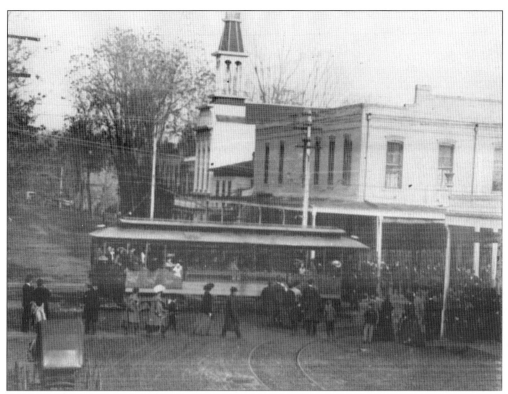

Citizens wearing their finery form a crowd at Second and Main Streets for a chance to ride the brand new Northern Electric Railway in 1905. Transportation had come a long way. The new rail line allowed passengers to travel to Oroville without a horse-drawn coach. Chico Fire Engine Company No. 1 is visible with its bell tower. (Courtesy of John Nopel.)

The trains are long gone, but Second and Main remains an important intersection. Second continues east and curves over Big Chico Creek, where it becomes Vallombrosa Avenue. Vallombrosa continues for about four more miles, hugging the perimeter of Bidwell Park. Pluto's restaurant occupies the southeast corner now. Its immediate predecessor was a short-lived recreation room called Mind Games. Preceding it were Diamond W Western Wear and Ken's Hooker Oak Office Furniture.

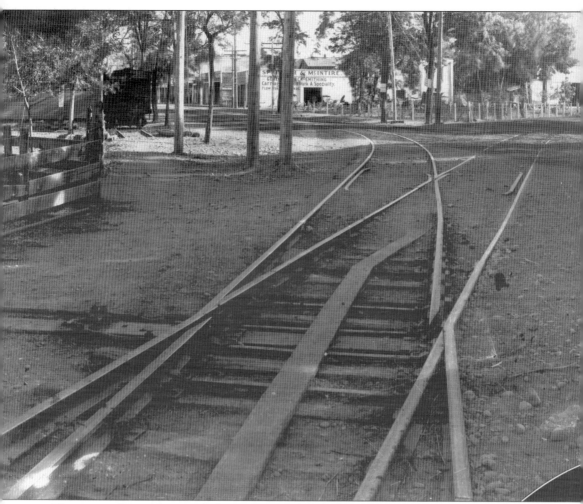

This extremely rare photograph shows an important confluence of Chico traffic around 1905–1907, shot from the bridge over Big Chico Creek looking south, with the Esplanade starting behind the photographer. Main Street begins here and curves to the left. The approximate date of the photograph is based on the fact that the Masonic Temple, built in 1908, is not visible at center right. However, the track of the Northern Electric Railway, completed in 1905, is plain to see. The rail line going to the right is a spur from the Western Pacific, which traveled along First Street to the main north-south line a little less than a mile away. This spur allowed traffic to reach the Sperry Flour Mill alongside the creek. The street that connects the Esplanade to Broadway resulted from this spur. Most people don't realize it has a name—Shasta Way—because there are no related signs or addresses. (Courtesy of John Nopel.)

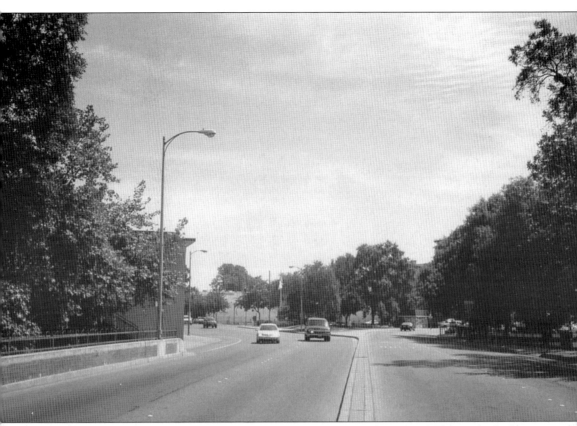

When the Sacramento Northern tracks were removed in 1989, the City of Chico rebuilt that side of the bridge to accommodate pedestrian and bicycle traffic. At center is Ringel Park, a three-sided area that once was home to service stations. All that remains of the final business on the site, a Shell station, are the restrooms that are now available for public use. Shasta Way, meanwhile, carries southbound traffic from the Esplanade to Broadway.

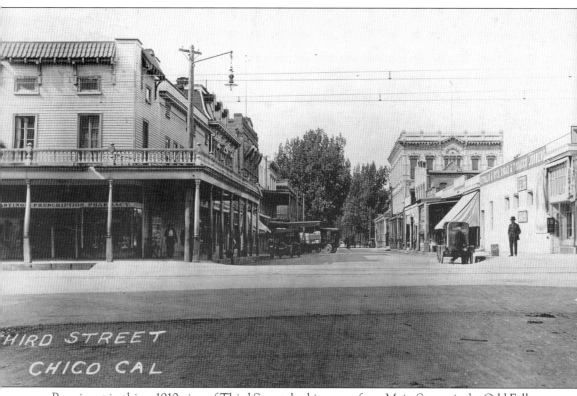

Prominent in this c. 1910 view of Third Street, looking west from Main Street, is the Odd Fellows Building alongside Broadway in the background. At left is the wooden Union Hotel. At right is the Jacobs and Oser department store, built in 1880. Morris Oser took over the business some years later and built an elegant two-story emporium in 1925. (Courtesy of John Nopel.)

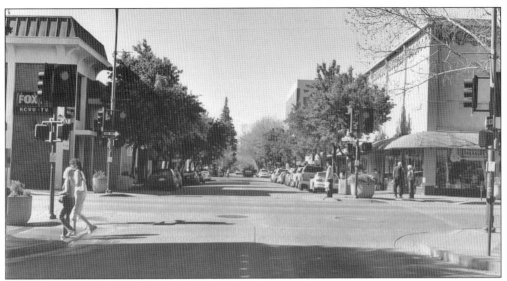

Today the corner of Third and Main Streets features the offices to television stations KRVU and KCVU, where the Union Hotel had stood. The current building was originally home to Crocker Bank, which later became Wells Fargo Bank. Now all that remains of the financial institution is an ATM. On the right is the Oser Building, which closed in 1986 after nearly 108 years as a prominent purveyor of clothing and household goods. A sporting goods store, Sports Ltd., moved into the spot, but vacated it in 2003 in favor of a location on Mangrove Avenue. Now there's an antique emporium in the two-story building. The Crocker-Citizens Bank Building, built in 1923 to replace the Union Hotel, had four stories and was home to the offices of many attorneys, doctors, and other professionals. It met the wrecking ball after only 46 years of existence.

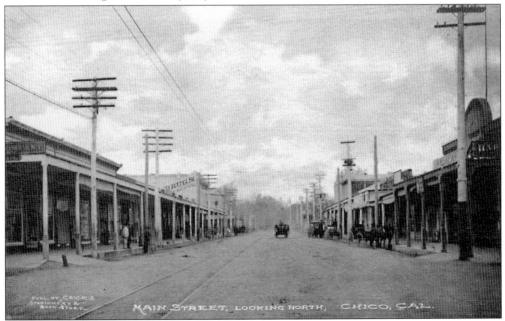

This c. 1908 postcard shows Main Street, looking north from Third Street, before it was paved but after the Northern Electric Railway was established. (Courtesy of Butte County Historical Society.)

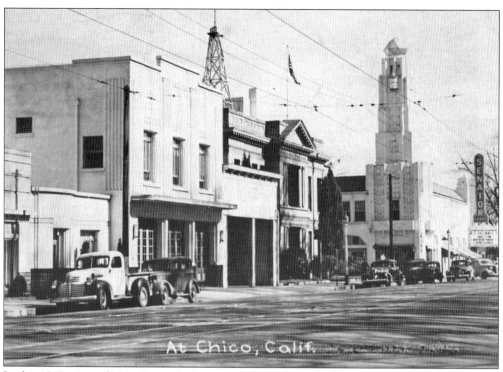

In this 1940s view of Main Street, looking south from alongside City Plaza, the Senator Theatre's stately art deco tower is visible, as is city hall at the corner of Fifth Street. The city fire department is north of city hall. (Courtesy of John Nopel.)

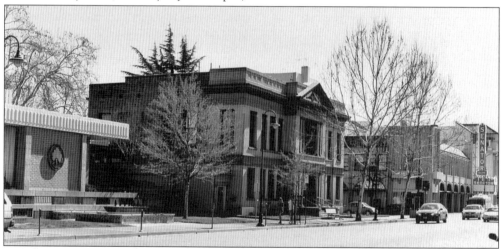

What's missing in this recent photograph? The Senator Theatre's tower was removed due to concerns over its stability in 1998. The tower, leaning noticeably toward Fifth Street, was condemned by city officials. Amid great public dismay, it was dismantled and placed in storage, with the hope it would be reassembled. Chico developer Eric Hart purchased the building after United Artists closed the Senator in 2000. He has restored the building's exterior and paid to have a replica made by the Chico Iron Works, replacing it on May 22, 2005. A little further down the street, at the corner of Sixth and Main, is a four-story building completed in 2004 by local businessmen Steve Gonsalves and Bob Linscheid.

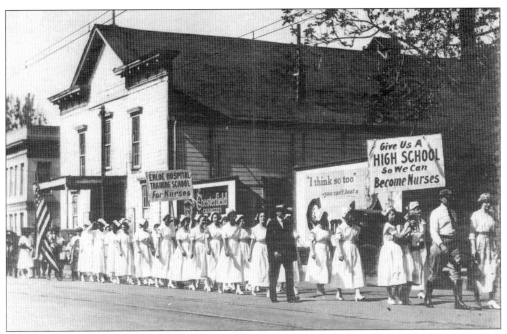

Dr. Newton Enloe, the gentleman in the knee-high boots at right, leads a parade of nurses south on Main Street in 1919. They're walking in front of the Armory, site of today's Senator Theatre. The old city hall is visible in the background. The nurses marched to encourage voters to approve bonds for a new high school on the Esplanade, that would provide facilities for training nurses. The bond measure passed and the school was built. These days Chico State University has a solid nursing program of its own. (Courtesy of John Nopel.)

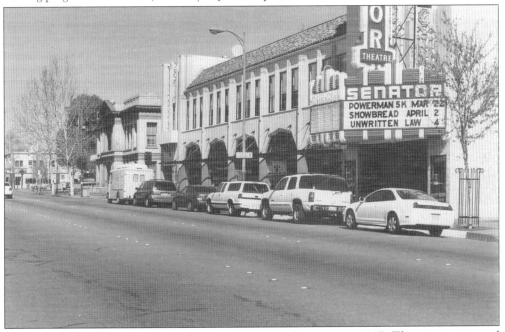

The Senator Theatre replaced the Armory at this location in 1927. The site is pictured above in 2005.

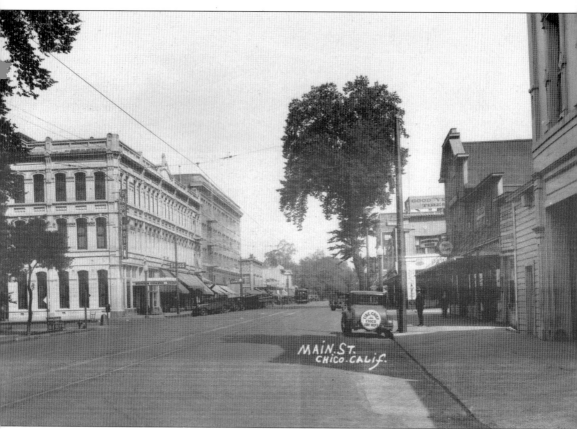

Main Street, looking north from near Fifth Street, is pictured on a sunny morning in the late 1920s. At far left is City Plaza, with the Park Hotel across the street. Behind the Park Hotel is the four-story First National Bank Building, which had replaced the rickety wooden Union Hotel that had occupied the site. At far right is the new city fire station, which sat just north of city hall (not visible). The spare-tire cover on the car reads, "Fire Chief, Chico Fire Department." (Courtesy of John Nopel.)

The block at left, beyond City Plaza, has endured perhaps more changes than any block in the heart of downtown. Gone are the Park Hotel (1963) and the Crocker-Citizens Bank Building (1969). Donohue's Menswear replaced the hotel, and Crocker built a modern facility that now houses television station KCVU. At extreme right, the fire station is gone, replaced by the Chico Municipal Center with the city council chambers, dedicated in 1975. In front of the center was a fountain that often malfunctioned; it was replaced by a water sculpture featuring dancing trout in 2003.

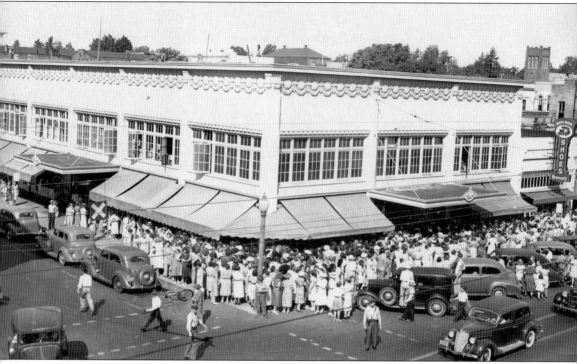

Everyone loves a bargain, as evidenced by this throng waiting to take advantage of a 1939 fire sale at M. Oser's department store at Third and Main Streets. Note the unpainted windows on the second floor of the building. They were covered in the remodeling after the fire, and another remodeling took place in 1958. The store's circular staircases were installed in 1966. Apparently the Chico Police Department expected many people at this event, as two officers try to direct traffic on Main Street. Oser's closed in 1986 when sales began to decline considerably. The store's owners never considered declaring bankruptcy, but could see the effects of chain retailers at local malls. A lack of parking for downtown businesses was another major concern that contributed to the decision to close after 108 years of business. An antique mall now occupies the building, though plans have been discussed to convert the place into smaller retail outlets. (Courtesy of John Nopel.)

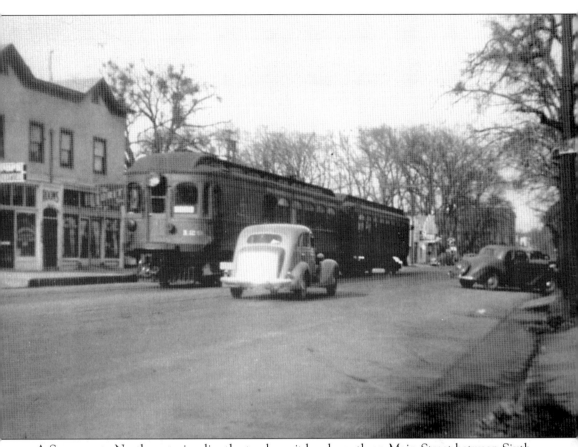

A Sacramento Northern train plies the tracks as it heads south on Main Street between Sixth and Seventh Streets in the mid-1940s. Train operators and drivers needed to be mindful of each other because of the limited width of the street. (Courtesy of John Nopel.)

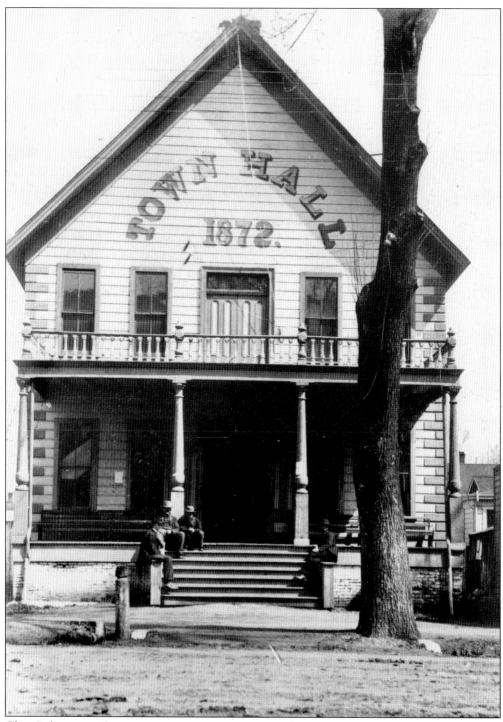

Chico's first seat of city government, on Main Street between Third and Fourth Streets, was completed shortly after incorporation in 1872. The wooden structure served as office and meeting space until 1911, when the brick municipal building was ready for occupancy at Fifth and Main Streets. (Courtesy of John Nopel.)

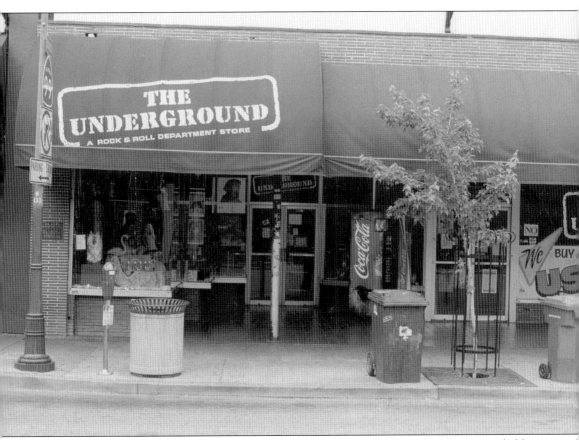

The site of Chico's first town hall is now occupied by an assortment of businesses in unremarkable masonry buildings, including Mr. Lucky, a nightclub; The Underground, a music and novelty store; and the Towne Lounge, a tavern. The former town hall site is marked by a plaque.

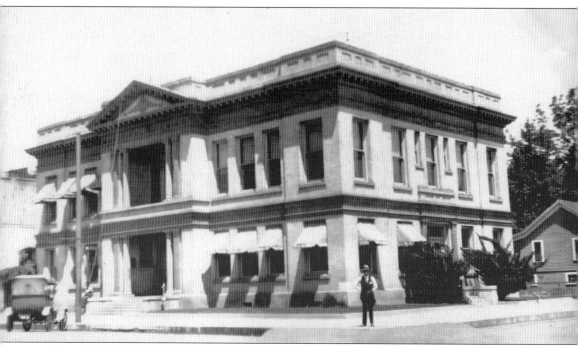

Chico's city hall was completed in 1911 and occupied until 1994, when the current facility was finished behind it. Located at the corner of Fifth and Main Streets, city hall housed all city offices except the fire department, which was located on East Second Street before moving to a modern facility just to the north of city hall in the 1920s. The city council held its meetings in the chambers upstairs, which were deemed inadequate by the 1960s. Meetings moved to the new municipal center in 1975, where they remain today. City hall, which has been shuttered since 1994, is set to become home to the Janet Turner Art Gallery, now located on the second floor of Chico State's Laxson Auditorium. The gallery can move in once seismic retrofitting and other needed improvements are made, at an estimated cost of $1.4 million. However, some of that is expected to be offset by a grant from the California Cultural and Historial Endowment. (Courtesy of Butte County Historical Society.)

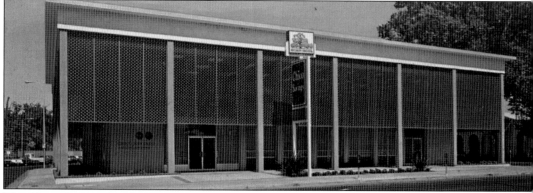

The Chico Savings building at 35 Main Street, just north of First Street, went up in 1962 after the Sacramento Northern depot was demolished. It housed financial institutions and legal offices until about 2000. Chico State University now owns the building and KCHO North State Public Radio is its main tenant, having moved from cramped quarters in the basement of the Meriam Library. (Courtesy of Butte County Historical Society.)

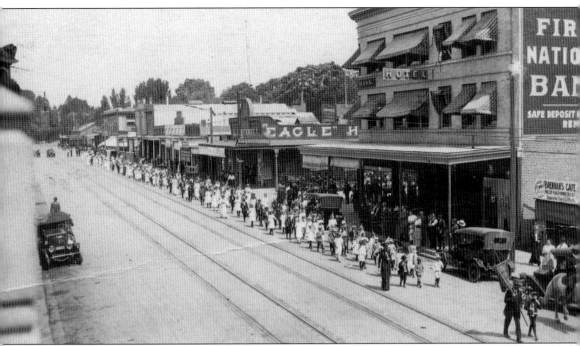

A c. 1920 school parade travels down Main Street in this view, looking north between Third and Fourth Streets. Newspaper articles show that Chico averaged 12 to 15 parades per year. Today's Parade of Lights, held in the evening in late June or early July, is the only annual parade Chico offers. However, there are efforts to revive the Pioneer Day Parade, which accompanied a weeklong event called Pioneer Days. It was held from the mid-1920s until drunken student riots at Chico State University caused Pres. Robin Wilson to cancel the event in 1987. Rancho Chico Days was instituted in an effort to revive the Pioneer Days spirit in the late 1980s and early 1990s, but it succumbed to a lack of interest. The Parade of Lights began in 1991 as the Lights of Victory Parade, recognizing the United States military during the Gulf War. (Courtesy of Butte County Historical Society.)

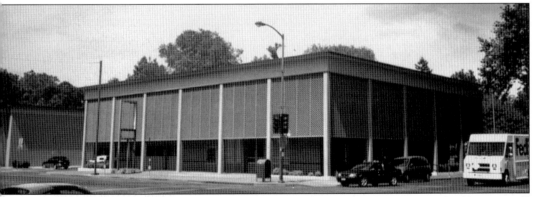

Today a City of Chico parking lot is behind the site of the old Chico Savings building, as well as private parking for the building's tenants. The building featured a marquee with an electronic sign until the early 1990s, when it was removed due to noncompliance with city sign codes. Residents miss the sign, because it gave accurate time and temperature readings to those traveling on Main Street.

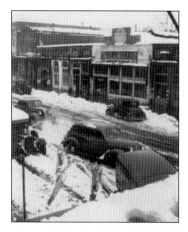

Main Street appears here after the massive snowstorm of December 1937. Since Shasta Dam had not been constructed yet, the Sacramento Valley endured enormous flooding as every stream and creek in the watershed overflowed. The winter of 1937–1938 remains the fifth-wettest rainy season on record with 41.08 inches, surpassed only by 1982–1983 (50.51 inches), 1997–1998 (49.68), 1940–1941 (45.79), and 1957–1958 (41.92). Chico's average annual precipitation is 25.11 inches. Snow is not unheard of in the area but is highly unusual, especially the volume of snow that fell here. Clearly most valley dwellers weren't prepared, and consternation resulted. (Courtesy of John Nopel.)

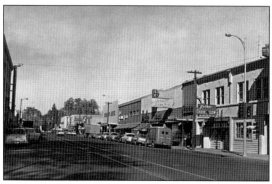

This 1966 photograph looks north from Fourth to Main Street. After the completion of the Highway 99 freeway (about a mile east), Main became a one-way street. It now has considerably less traffic than when it was part of the crucial north-south artery on this side of the Sacramento River. At far left is the four-story Crocker (First National Bank) Building, that met the wrecking ball three years later. (Courtesy of Butte County Historical Society.)

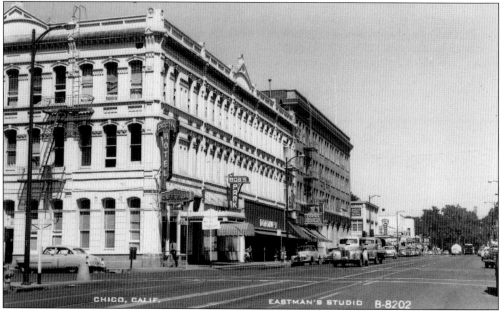

Pictured here is Main Street, looking north at its intersection with Fourth Street in the late 1940s. Just beyond the photograph at left is City Plaza. In view is the Park Hotel, built in 1885 and demolished in 1963. (Courtesy of Butte County Historical Society.)

Three
THE BIDWELLS

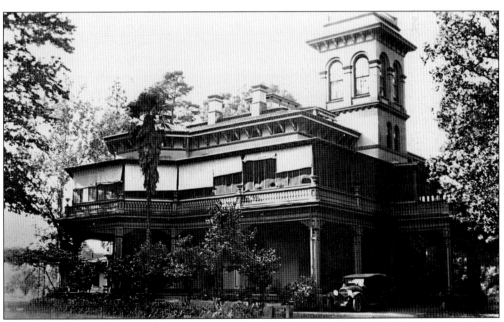

This is how Bidwell Mansion appeared in the 1920s after becoming a part of Chico State Teachers College. It was used at various times as classroom and dormitory space, named Bidwell Hall until the early 1960s, when it was reclaimed by the state as a historical site. (Courtesy of John Nopel.)

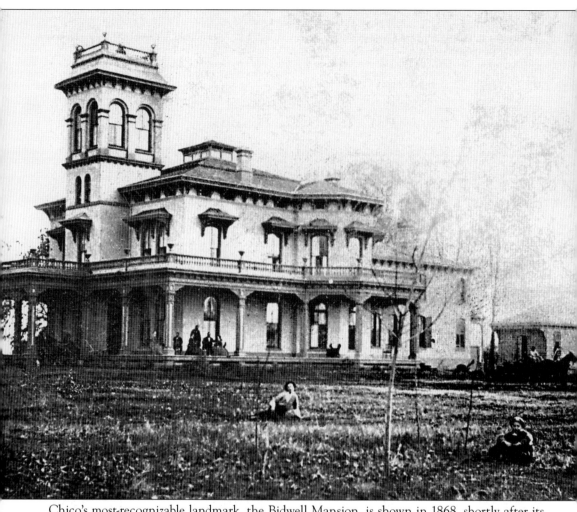

Chico's most-recognizable landmark, the Bidwell Mansion, is shown in 1868, shortly after its completion, but before any landscaping was in place. John Bidwell, who came to California from New York in 1841, acquired a huge Mexican land grant upon which he established Rancho del Arroyo Chico, "Ranch of the Little Creek." A bachelor, Bidwell had served in the military and was later accorded the title "general" during peacetime. He successfully ran for Congress in 1865. While in Washington, D.C., he met Annie Ellicott Kennedy, 20 years younger than John and the daughter of a well-to-do capital family. Annie thought John was a very interesting man, and while she wasn't inclined to marry him, she wanted to maintain a friendship through correspondence. However, in the next couple of years, John's persistence paid off and he won Annie's hand in marriage. The Bidwell Mansion was his wedding gift to her, where she lived the rest of her life. (Courtesy of John Nopel.)

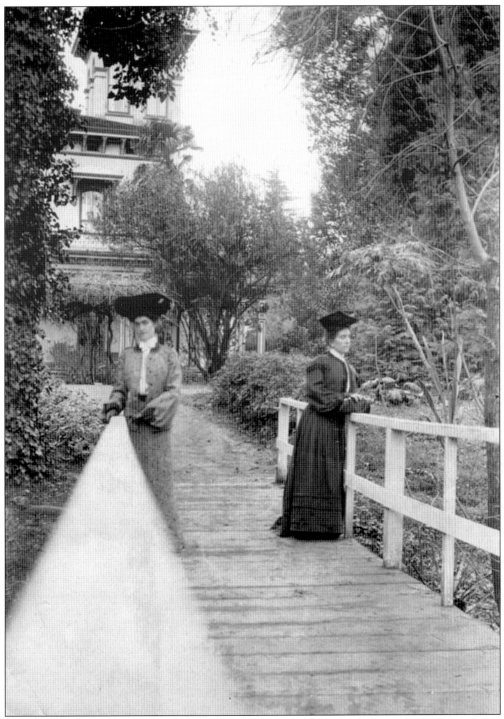
Two ladies in classic Victorian dress pose for a photograph on the Bidwell footbridge over Big Chico Creek in 1890. A bridge, constructed in the early 1980s, occupies the site now and serves as a well-used conduit for pedestrians and cyclists between So-Will-Len-No Drive and Children's Playground. (Courtesy of John Nopel.)

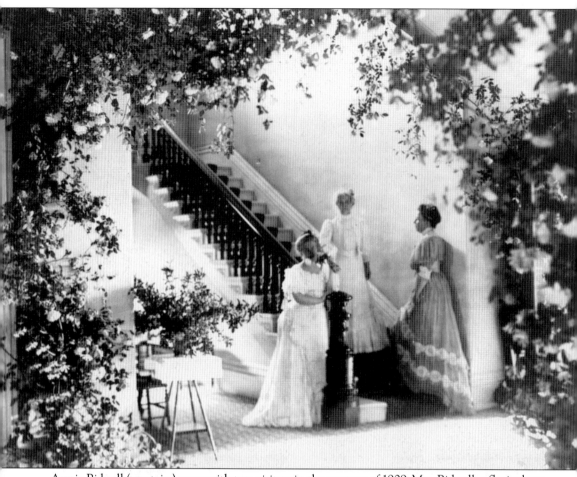

Annie Bidwell (on stairs) poses with two visitors in the summer of 1909. Mrs. Bidwell, a floriculture enthusiast with a considerable garden on the mansion grounds, frequently had many plants and flowers adorning the mansion's interior. It was a luxury that wasn't available for much of the year in her native Washington, D.C., since the Central Valley of California enjoys a longer growing season and allows for a wider variety of flowers to thrive. (Courtesy of John Nopel.)

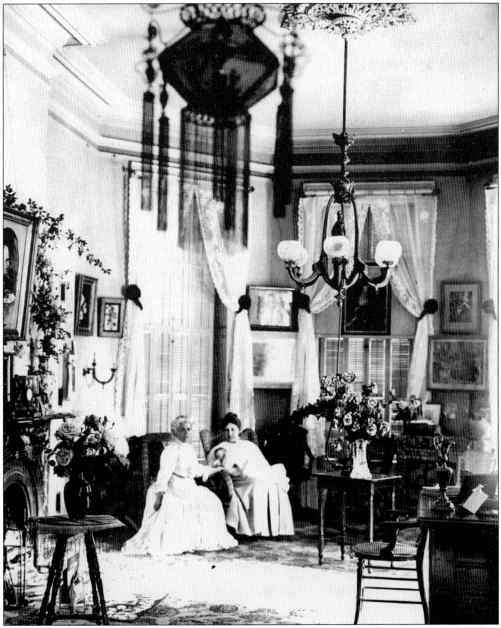

Mrs. Bidwell, left, entertains a guest over tea in the mansion's library in 1911. Imagine the discomfort ladies of the day must have endured in summer months because of their long, heavy dresses. (Courtesy of John Nopel.)

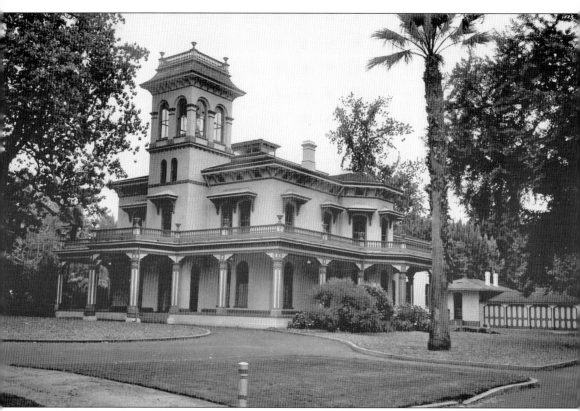

Today the mansion boasts a restored carriage house at right rear. A visitors' center, which contains a gift shop, now gives tour attendees background on the mansion as well as the Bidwells' influence on the region. Mrs. Bidwell deeded Bidwell Park to the City of Chico in 1905, completing a gift she and John had planned before his death in 1900. Now the eighth-largest municipal park in the nation, it supports a remarkable variety of plant and animal life from the valley floor to the rocky bluffs of the Sierra Nevada foothills. A reenactment of Mrs. Bidwell's presentation of the deed was held at the mansion on July 10, 2005.

Four
ACADEMIA

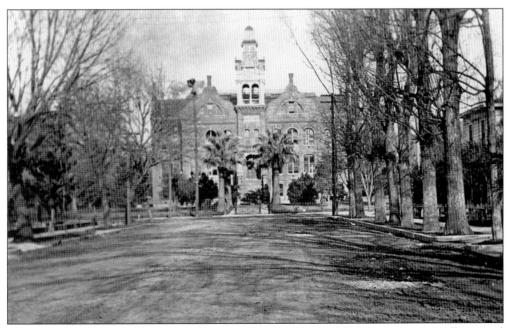

Pictured c. 1910, Normal Avenue, between First and Second Streets, was originally named Sycamore Street, but the name was changed with the arrival of Chico State Normal School in 1887. (Courtesy of John Nopel.)

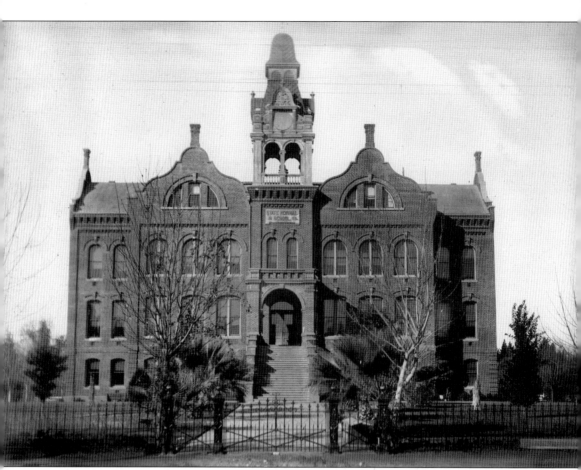

Pictured is Chico State Normal School, officially named the Northern Branch of the State Normal School, as it appeared in the winter of 1896–1897. In the early days, Normal Avenue (the street that runs perpendicular to the site) was known as Sycamore Street, keeping with John Bidwell's tradition of naming north-south streets after trees. With the arrival of the Normal School building in 1889, however, it was renamed Normal Avenue. The facility was gutted by a fire in 1927, and its shell was demolished. The school, established in 1887, became known as Chico State Teachers College in 1921, Chico State College in 1935, and California State University, Chico, in 1972. In casual parlance, just about everyone calls the institution Chico State University. (Courtesy of Butte County Historical Society.)

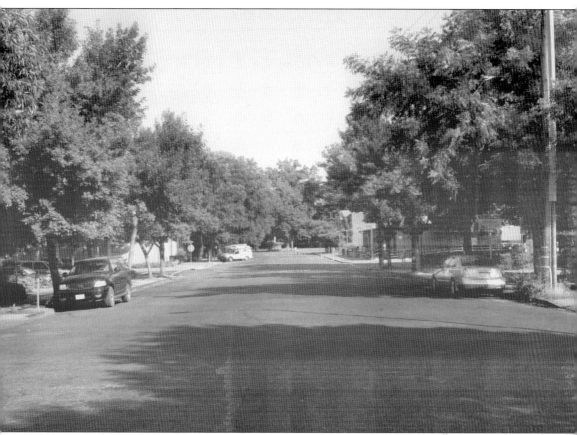

Normal Avenue remains, but today's view is quite different. A saloon and a handful of other businesses now line the block between West Second and Third Streets, but the area is purely residential from that point south. Through traffic can go no further north than Second Street. The old Normal School building no longer dominates the end of the street; now it's the Spanish-Colonial Revival Kendall Hall.

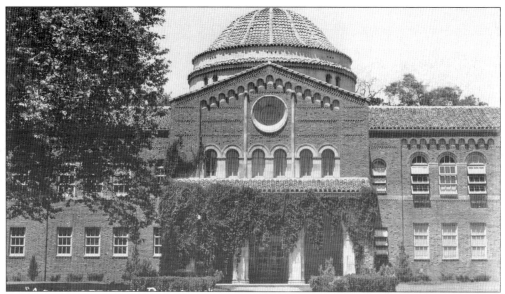

Chico State College's administration building no longer contains any classrooms or faculty offices, as it did when this photograph was taken around 1940. The building was named after Glenn Kendall, Chico State president from 1950 to 1966, during homecoming festivities on October 6, 1979. Many students have pondered the philosophical "Today Decides Tomorrow" motto engraved above the main entrance. (Courtesy of John Nopel.)

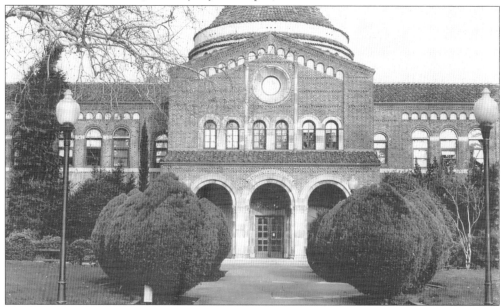

Perhaps the most striking feature of Kendall Hall's landscaping is the circular set of evergreens along the main entrance path. Inside the bushes is a concrete circle, and around its perimeter are two-digit numbers from 31 to 58. Each number represents a Chico State class, with the corresponding year in which the class buried a time capsule. Some of these have been opened in the past few years during milestone celebrations. There are a few time capsules near the front steps to the building, after the circle ran out of space. The practice died out after 1969, but was revived in 2000 thanks to efforts by the alumni association.

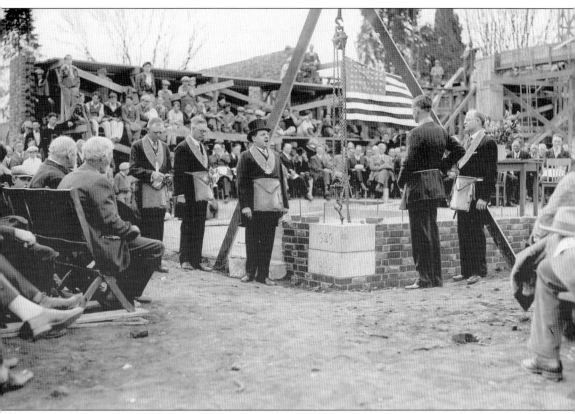

Masons from Chico Lodge No. 111 perform the ceremony as the cornerstone is placed on the new Chico State College administration building March 3, 1929. It's the same cornerstone that anchored the old Normal School building, with "1889" below the new "1929," signifying the year of the new building's completion. Inside was a strongbox—an 1889 time capsule with materials sealed inside. There was considerable public debate as to whether the box should be opened before being sealed again in 1929, but it was left sealed and put inside the cornerstone. Today's administration building is on the same site where the original facility once stood. (Courtesy of John Nopel.)

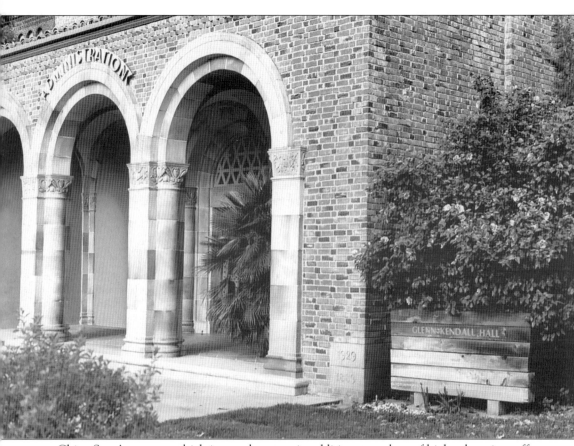

Chico State's campus, which is an arboretum in addition to a place of higher learning, offers a wealth of trees and plant life. Here Kendall Hall is surrounded by mature bushes and trees, in stark contrast to the cornerstone ceremony more than 75 years earlier, when the landscape was barren following the Normal School building's destruction.

Chico State College's gymnasium was built in 1927. Prior to the gym's construction, Chico State had no court large enough for its basketball team to compete. Instead, the teams "hosted" games at area high schools as far away as Corning and Oroville. Even with the gym, however, Chico State began playing its home games at the modern Chico High School gym in the late 1940s, where it remained until what is now called Jane Shurmer Gymnasium was built along Warner Street in 1956. This old gym met the wrecking ball in 1960. (Courtesy of John Nopel.)

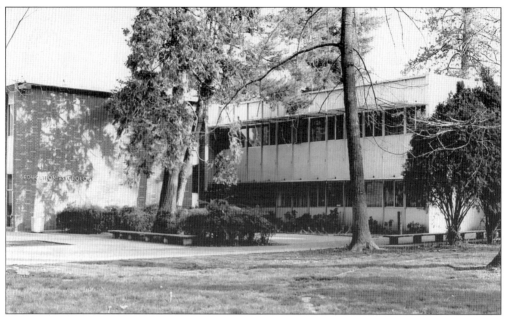

The site along Arcadian Avenue is now home to Modoc Hall, built in 1962, in which the university's education and child development departments are located. At the north end is the Child Development Laboratory, a preschool-type facility in which children who attend are observed by Chico State students in the education program. The building housed the psychology department until 1972.

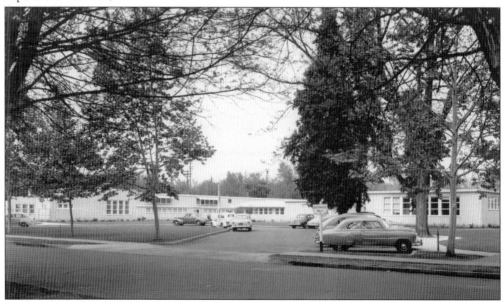

Aymer J. Hamilton School, on the east side of Arcadian Avenue, was built in 1949 next to Modoc Hall. The facility served as Chico State College's training school, an actual elementary school drawing neighborhood students, but not a part of the Chico school district. Instead, youths received instruction from student teachers, who were under supervision of education department professors. The school closed in 1971, and the building was converted to office and classroom space for the university. (Courtesy of John Nopel.)

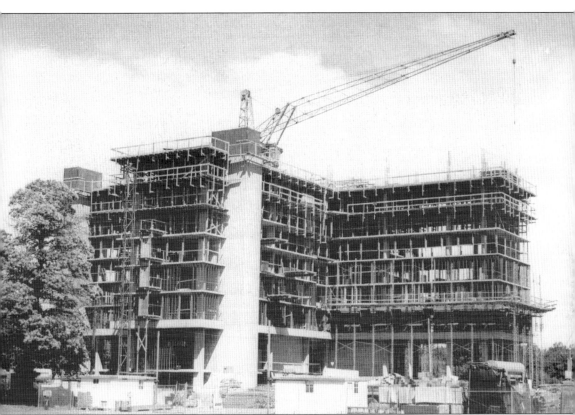

Construction of the 10-story Whitney Hall dormitory at Chico State College was underway in September 1967. It was finished in 1969, when, much to the dismay and embarrassment of local officials, the Chico Fire Department realized its tallest truck-mounted ladders couldn't reach the top of the building. Students chose the name "Whitney" because Mount Whitney is the state's highest peak, just as the building became the tallest at Chico State, as well as in the city. Dedicated on October 25, 1969, the dormitory offers 116,000 square feet of space and has rooms for nearly 550 students as well as a dining hall and recreation area. (Courtesy of John Nopel.)

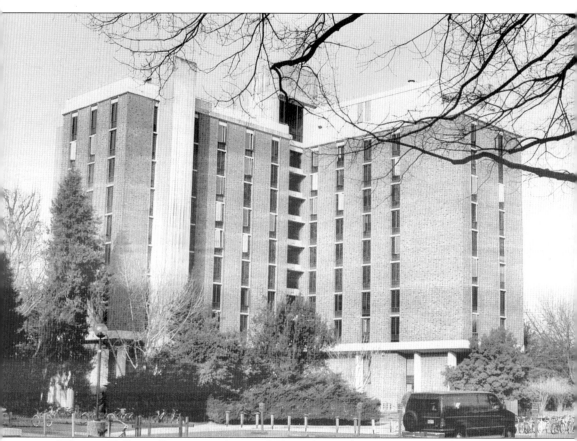
Whitney Hall is still an integral part of Chico State's dormitory system, though a recreation facility for all campus residents was built alongside it in 1984. In 2003, state university officials announced that it would be cheaper to demolish and rebuild Whitney than to try to renovate the tower for utilities, water, and technology. No timetable for this project has been announced, however.

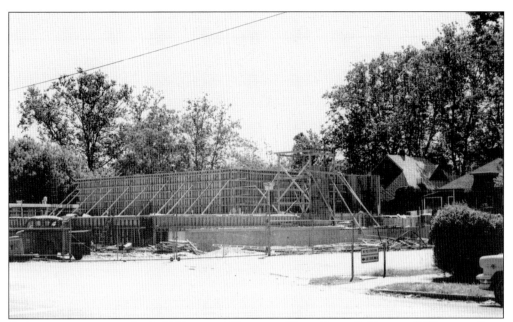

Early construction on the Bell Memorial Union at Chico State College in 1968 is seen here from West First Street. When finished in 1969, the building housed the Associated Students headquarters as well as the school's bookstore and featured 52,000 square feet of floor space on three stories. With the rapid increase in enrollment, however, Chico State officials realized the building was becoming inadequate by the early 1980s. A bond measure was finally passed in 1996. (Courtesy of John Nopel.)

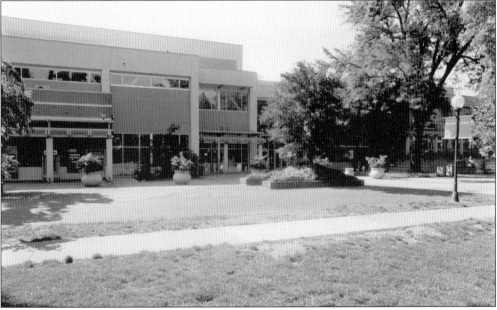

The BMU, as students and locals call it, is bigger and shinier than ever, following a massive expansion and renovation completed in 2000. It now features a multi-use room capable of seating 1,000 people, along with a larger bookstore, new AS offices, a cafe, a coffee shop, and numerous facilities catering to the comfort and recreation of students.

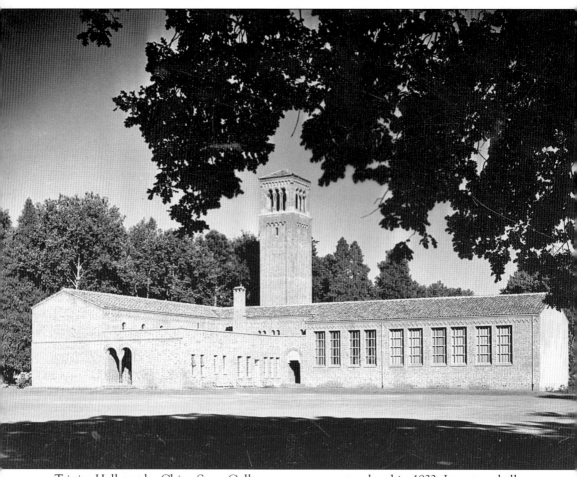

Trinity Hall on the Chico State College campus was completed in 1933. Its square bell tower resembles campaniles found in Italy. It's one of the university's most easily recognized buildings because of its tower, which housed chimes from 1937 until 1966. The chimes rang every quarter-hour to help those within earshot keep track of time. The chimes began to age, however, and citizens, students, and alumni raised $6,000 to install carillons in 1966 in honor of Glenn Kendall, who was retiring as college president. The carillons chime every half-hour from 8 a.m. to 8 p.m. Monday through Saturday, and from noon until 6 p.m. Sundays. (Courtesy of John Nopel.)

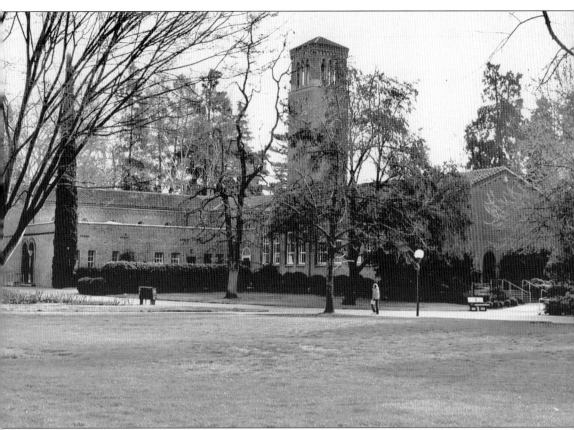

Trinity Hall, pictured in 2005, was home to the library, the student union, classrooms, and offices until it was remodeled and underwent a seismic retrofit in the early 1970s. The library's contents were moved just a few yards away to the $6.8-million Theodore Meriam Library, completed in 1974, which offered 249,323 square feet of space, making it the largest building in the state north of Sacramento. Trinity Hall earned its name in 1972, as the university began the practice of naming many campus facilities after Northern California counties.

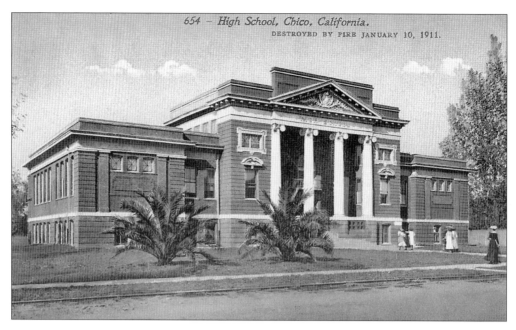

Chico High School, pictured above at its original location on West First Street in 1912, was refurbished after a fire gutted the brick building on January 10, 1911. Even before the fire it was already showing signs of overcrowding due to Chico's growth. A beautiful reddish-orange brick building, shown below, was financed by bonds passed in 1919 and finished in time for the 1922–1923 school year at 901 The Esplanade, site of the current school. The old building on First Street then became Central School, serving students in grades 6-8, until Chico Junior High School was opened in 1953. The aging building, in severe need of upgrades in wiring and plumbing, was considered to be too much of a liability, and was demolished. Meriam Library at Chico State University now occupies the site. (Courtesy of Butte County Historical Society.)

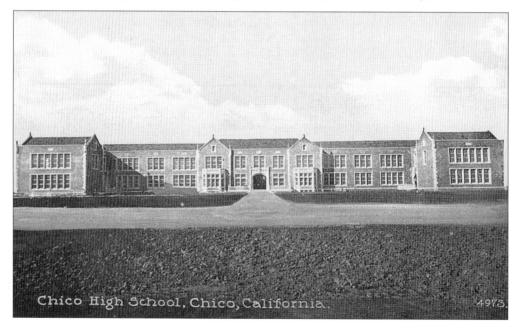

Finished in 1877, the original Oakdale School, which was near Park Avenue at West Eleventh Street, appears here about 1910. Three communities existed south of Little Chico Creek in the early 20th century—Barber, which thrived due to the Diamond Match factory; Chapmantown, a little bit east of Park Avenue; and Oakdale, more to the south along Park Avenue. Oakdale Street still exists as a nine-block-long reminder of those days. (Courtesy of John Nopel.)

A modern Oakdale School was constructed on the site in 1924, featuring solid masonry in the Spanish Colonial Revival style. The school was demolished in 1950, due to concerns about fire and earthquake safety. It was replaced by a nondescript modern building, which also served as Oakdale School until 1975, when it was reconfigured for use as Fairview High School, a continuation school for high school–aged students. (Courtesy of Butte County Historical Society.)

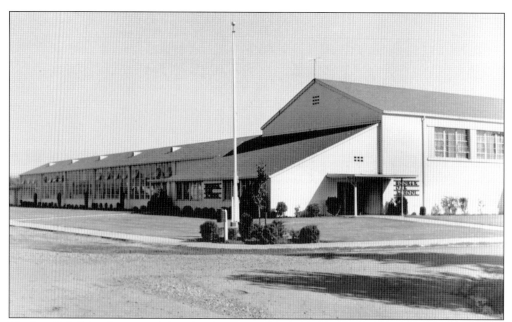

Hooker Oak School, pictured shortly after its completion in 1948, was built to serve the rapidly growing neighborhoods in northeastern Chico, with many of the houses built in the 1930s and 1940s. John Nopel, whose vintage photographs appear in this book, was named as the first principal. East Third Avenue, which is seen at left in this photograph, and Arbutus Avenue, which goes right, had not yet been paved. (Courtesy of John Nopel.)

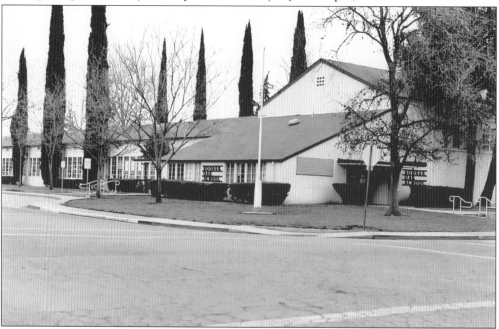

Hooker Oak still serves students in kindergarten through sixth grades, but features an open-structure classroom (OSC) program, providing an alternative style of education to parents. The school still offers traditional classes for neighborhood students, though children in the OSC may come from anywhere in the Chico Unified School District.

Five

THE ESPLANADE
CHICO'S GRAND BOULEVARD

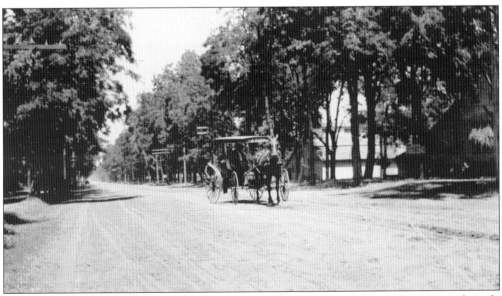

A horse-drawn buggy glides along The Esplanade in the late 19th century, when it was a heavily traveled dirt road. Still, it was a crucial link between the farms north of town and the commercial district. The area was known in those days as Chico Vecino, or "Chico's Neighbor."

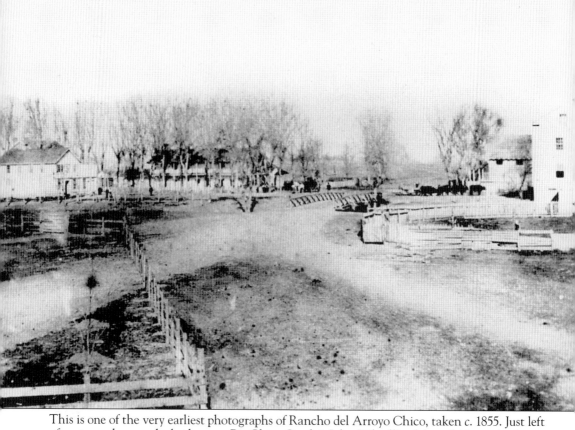

This is one of the very earliest photographs of Rancho del Arroyo Chico, taken c. 1855. Just left of center and across the bridge over Big Chico Creek is John Bidwell's adobe, which was his home until he finished construction of the mansion in 1868. To the left of the adobe is the Bidwell Store; across the road are the flour mill (far right) and a hotel. The road that meanders through is the old Shasta Road, serving as a crucial stage line for those seeking their fortunes in the gold mines of Shasta and Trinity counties. Today that road is The Esplanade north of the creek and Main Street south of it. (Courtesy of John Nopel.)

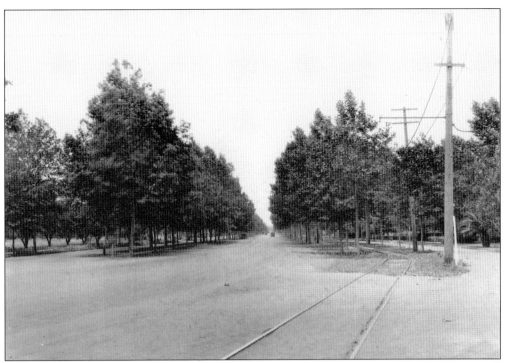

Just a little north of Big Chico Creek is the slight bend where The Esplanade crosses Memorial Way. Here is a 1920s view showing relatively little traffic. (Courtesy of John Nopel.)

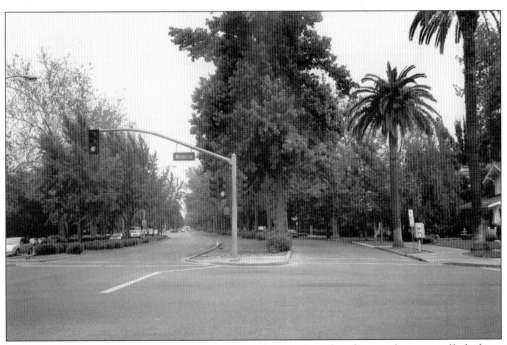

The Esplanade, pictured here in 2005, was repaved in 1995, with right-turn lanes installed where the railbed had once been. The street's trees create explosions of yellows and reds in the early weeks of autumn.

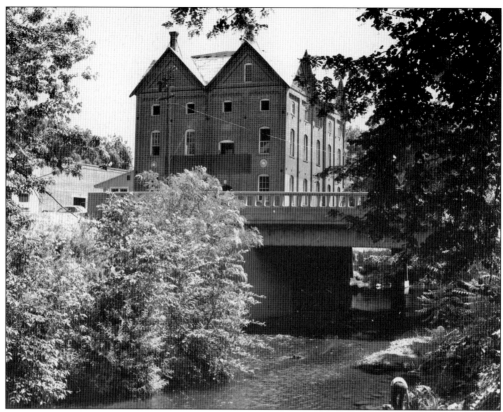

Sperry Flour Mill, on the north bank of Big Chico Creek across from the Bidwell Mansion, used water power from the creek to crush grain into flour. The flour was then shipped off on trains that used the rail spur fronting the building. The facility, built in the 1870s and pictured here around the turn of the 20th century, replaced the mill John Bidwell operated on the same site from the earliest days of Rancho del Arroyo Chico. (Courtesy of John Nopel.)

The mill, located conveniently next to Northern Star Mills (a dealer in feeds, grains, and other such goods), was demolished in 1959. On the site now are the Bidwell's Mill Apartments, built in the mid-1960s and catering mostly to college students.

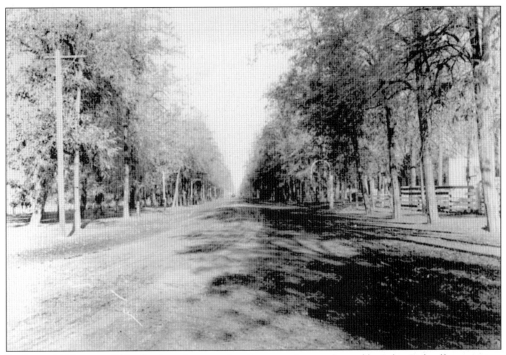

In this c. 1910 view of The Esplanade, note the six rows of trees planted by John Bidwell—creating the lanes for travel. Four rows still exist, but the middle two rows were removed to accommodate modernization of The Esplanade once Highway 99E was relocated. (Courtesy of John Nopel.)

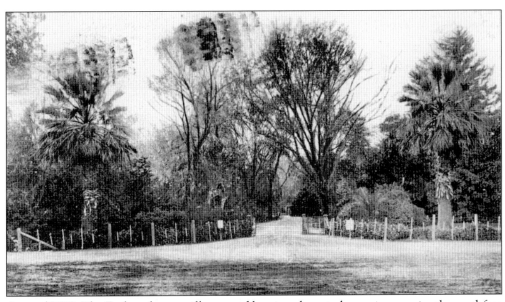

Around 1920, The Esplanade was still unpaved but was closer to becoming a major thoroughfare by its designation as U.S. Highway 99E. Here it fronts an entrance to Rancho Chico, with the Bidwell Mansion obscured by trees. (Courtesy of John Nopel.)

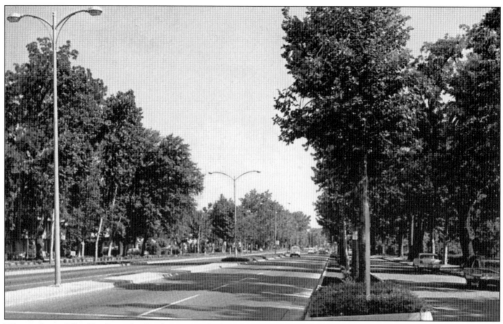

This is how The Esplanade, looking south from Second Avenue in the mid-1960s, appeared shortly after its reconfiguration, when two rows of trees down the middle of the street were removed to make it a four-lane stretch. Previously there were six rows of trees spanning the street; two of them are visible at right. U.S. Highway 99E was on this site before the freeway was completed in 1965, relieving The Esplanade of a lot of heavy traffic. (Courtesy of John Nopel.)

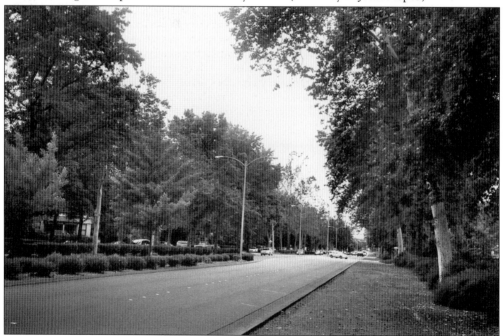

With mature trees and a repaving job in 1995, The Esplanade remains Chico's grand boulevard. It's also one of the busiest north-south thoroughfares in town, perhaps the easiest to drive due to its timed traffic signals to help ensure a steady vehicular flow.

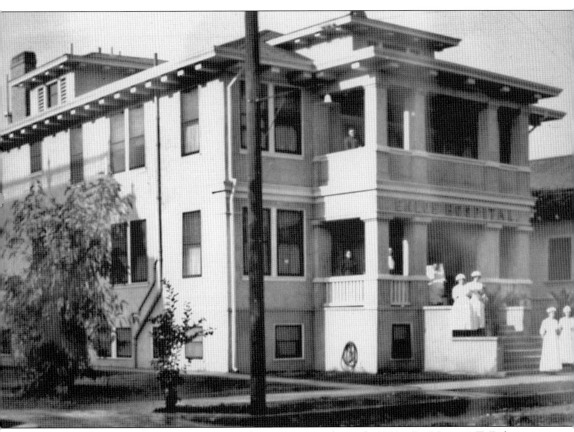

Enloe Hospital's original location was on Flume Street in the early 1930s. Dr. Newton T. Enloe, who had served as a Sierra Logging Company physician in the late 19th and early 20th centuries, built a one-room "hospital" in the mountains east to Chico to treat injured lumberjacks. As Chico began to grow, with nearly 4,000 residents by 1910, Enloe saw the need for a comprehensive hospital that the town had not previously enjoyed. He built this hospital between Third and Fourth Streets on Flume in 1913, featuring a revolutionary idea for the area, motorized ambulance service. (Courtesy of Enloe Medical Center.)

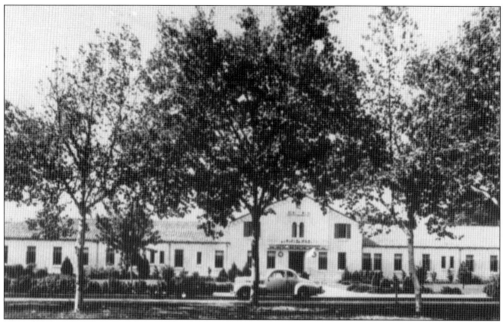

Chico continued to grow and prosper, and it was obvious that the Flume Street facility was becoming inadequate. In 1937, Dr. Enloe bought a parcel of land at 1531 The Esplanade in Chico Vecino and constructed the ultra-modern Enloe Hospital that has remained on the site ever since. It featured room for 60 patients and had two operating rooms, along with the very latest in medical technology. As it had on Flume Street, the new building offered a maternity ward. (Courtesy of Enloe Medical Center.)

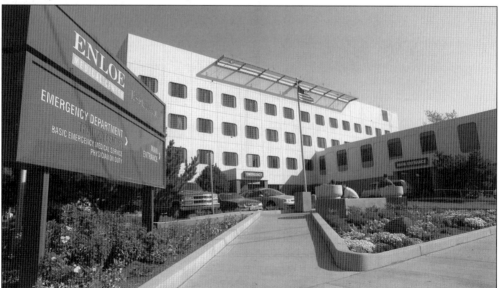

Enloe Medical Center today. The four-story addition with the main entrance moved to Magnolia Avenue was completed in 1980, including a trauma unit, cancer center and burn center. A controversial plan has been proposed to expand the hospital by demolishing several homes along Magnolia to make room for a parking structure as well as other modernizations. (Courtesy of Enloe Medical Center.)

Six
AROUND AND ABOUT

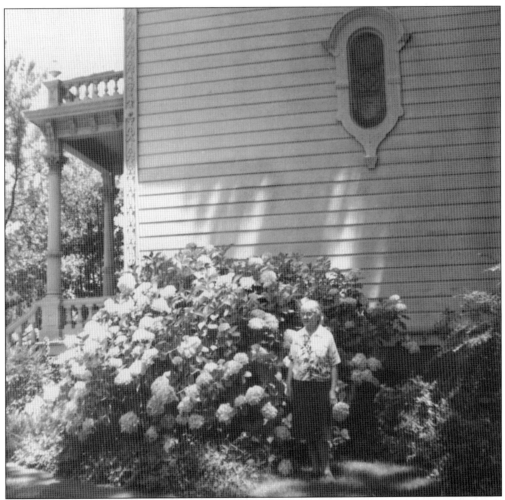

The Stansbury Home, at the corner of Fifth and Salem, was built for Dr. Oscar and Libbie Stansbury in 1883. Angeline Stansbury, one of their two daughters, stands beneath the stained-glass window at the side of the house in this June 1969 snapshot. Angeline was born in the home in 1883 and lived there all her life—91 years. The City of Chico acquired the home in 1976, and a local citizens group operates it as a house museum.

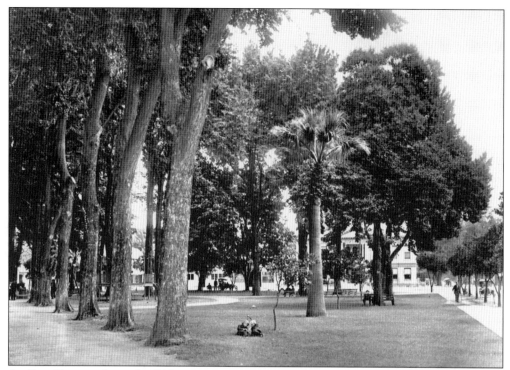

At City Plaza in the early 1920s, cars were becoming the rule, and two of them appear here parked along the plaza's perimeter. The old city hall building is visible in the background at right, and orange trees line West Fifth Street. John Bidwell originally designated City Plaza as "Court House Square," fully anticipating that Chico would wrest the county seat away from Oroville and a grand government building would rise here. Elections for this purpose in 1873, 1874, 1892, and 1914 failed, and Oroville has remained the seat ever since. Most Chicoans would likely prefer City Plaza as a park, anyway. (Courtesy of John Nopel.)

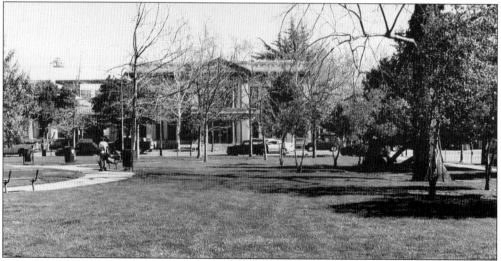

City Plaza looks a bit less lush without the elm trees that were removed in 2003. The park is about to undergo a redesign, helping it to once again be an attractive place to rest, visit friends, or listen to concerts on Friday evenings in the summer.

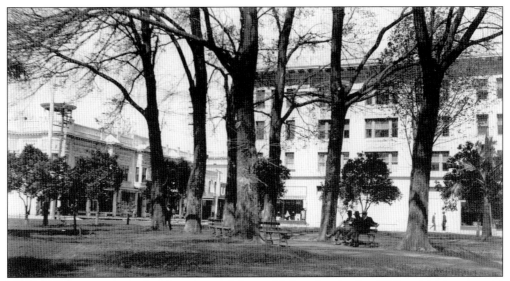

Three gentlemen enjoy a break on one of the park's benches in the 1920s, with the turreted Morehead Building and the Waterland-Breslauer Building clearly visible. At the time of this photograph, the elms planted by John Bidwell in 1874 were approximately 50 years old. (Courtesy of John Nopel.)

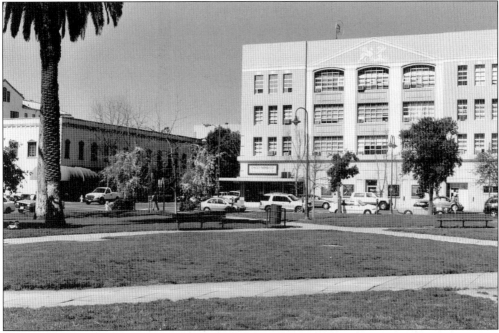

Even mighty elm trees don't live forever, and the City of Chico was obliged to remove City Plaza's elms when tests showed many of the trees had hollow interiors and severe rot. Apparently early 20th-century pruning practices weakened the trees, as did piling dirt around their bases. Hundreds of citizens objected to the city cutting down the trees, but safety concerns prevailed, and the elms were efficiently removed. As of 2005, the park is set to undergo a massive renovation, including a larger bandstand, restroom facilities, modernized lighting, and reconfigured parking around the perimeter.

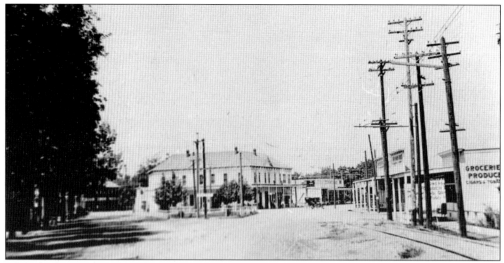

Chico had more than one "downtown." Pictured here is an area known for decades as the Junction, the triangular place bordered on the north by Ninth Street, as well as Oroville Avenue (left), and Main Street (right), which merged at Little Chico Creek. The area gained prominence in 1864 when John Bidwell and partners constructed the Humboldt Wagon Road Company stage line to Ruby City, Idaho, in response to new gold strikes there, known as the Humboldt Road. It began at what is now Humboldt Avenue, which had its western terminus at the Junction. Hotels, saloons, and stores provided stage passengers with everything they needed. A passenger could expect to reach Ruby City through Susanville at the blazing-fast speed of 16 days. Railroads established in the 1870s caused the decline of the Humboldt Road. (Courtesy of John Nopel.)

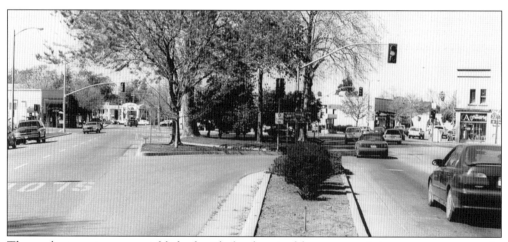

The park at center was established with funds raised by a women's improvement group in 1906–1907. It's a peculiar bit of greenery, as there are no crosswalks, so a person must jaywalk in order to get there. A small drinking fountain is the only feature aside from the trees. At left, on the corner of West Ninth Street and Oroville Avenue, sits Chico Volkswagen, on the site where the Volpato car dealership conducted business since 1923. Beyond the park is a Chevron gas station. Known as the Denver Rooms when it opened as a hotel in 1925, the building at right is now a collection of artists' lofts and other miscellaneous spaces. The "Junction" name still fits—it's the place where Highway 32 meets downtown commerce, and where Park Avenue meets Main Street going north.

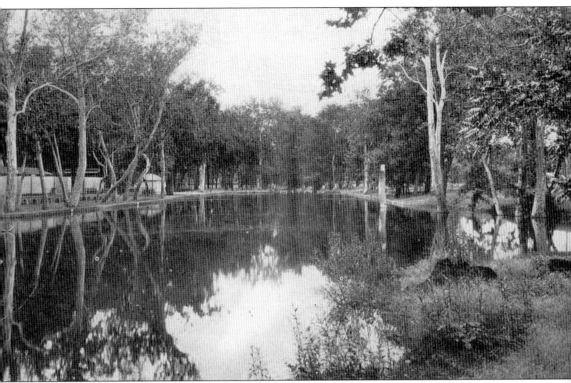

Sycamore Pool along Big Chico Creek is located at the One-Mile Recreation Area in Bidwell Park. The creek is dammed every spring, creating the pool that has provided relief from Chico's blazing summers to thousands of citizens and visitors since the 1920s. Some people are incredulous to learn that waterskiing demonstrations were held from time to time at the site in the 1950s. (Courtesy of Butte County Historical Society.)

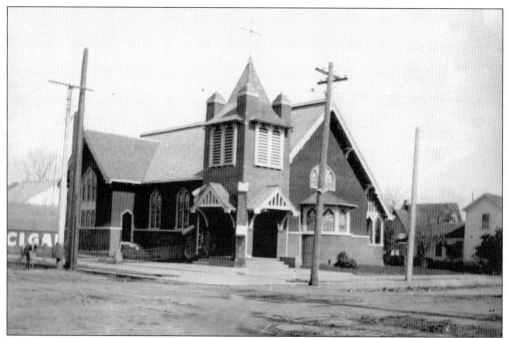

St. Andrew's Episcopal Church was completed in 1905. But take a closer look: the church isn't located in this photograph where it is today. Here it's shown shortly after completion on the southeast corner of West Fifth Street and Broadway. However, it was moved in 1912 after the federal government decided the parcel would be a good place for its permanent post office, completed in 1914. (Courtesy of John Nopel.)

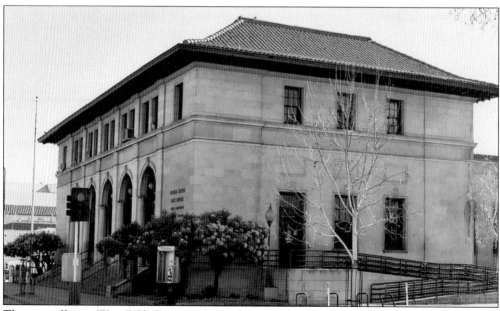

The post office at West Fifth Street and Broadway, pictured here in 2005, served as Chico's only post office until 1961, when the larger Vallombrosa Avenue facility was completed.

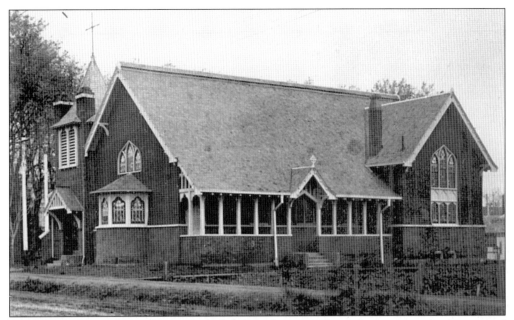

St. Andrew's Episcopal Church is pictured a few years after being relocated to its present site. (Courtesy of John Nopel.)

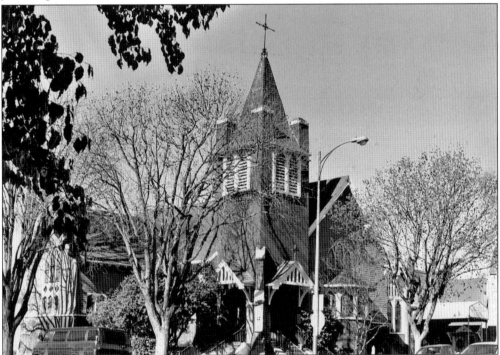

The same church is now located at the corner of West Third and Salem Streets. It hasn't always been a church; in the 1980s, it was abandoned as a house of worship, and in 1982 it became the Dynasty Chinese restaurant on the ground floor, and the Shell Cove nightclub in the basement. The Episcopals moved to reclaim the church in 1994, reopened it, and it thrives today. In 2005, the congregation celebrated the church's centennial.

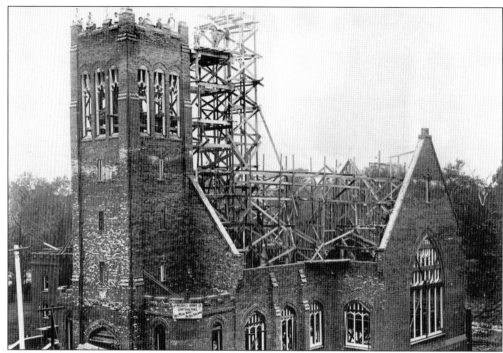

In the 1909 image above, construction is underway on the Chico Presbyterian Church and workmen are visible at the top. The original church, completed in 1870, was built on land donated by Gen. John and Annie Bidwell. When part of the facility was destroyed by fire in 1908, Mrs. Bidwell helped underwrite its reconstruction. Nichols Hardware, a longtime commercial anchor in downtown Chico, provided some of the materials for the new church, as written on the sign. The church burned again in 1931, but was rebuilt to its present form and dedicated in February 1932 as Bidwell Memorial Presbyterian Church, in honor of its patrons. To the right in the image below is the entrance to Rancho Chico, now Children's Playground, a gift to the City of Chico from Mrs. Bidwell in 1911. (Courtesy of John Nopel.)

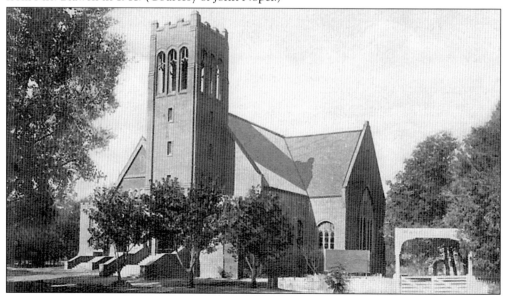

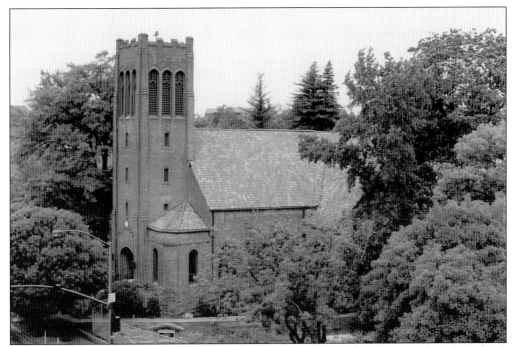

Renovations were in progress on the Presbyterian church at the time of this book's publication, but the congregation found a convenient meeting site nearby—the El Rey Theater, which closed as a movie house in March 2005.

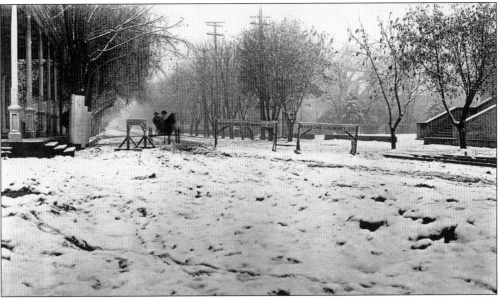

This 1916 photograph of West First Street, looking west from Broadway, was taken after a snowfall. At right are the steps to the Chico Presbyterian Church; at left is the walkway alongside what is now Tres Hombres restaurant. The barricades in the street read "Streets Closed—Ransome-Crummey Co." Clearly the folks riding in the horse-drawn buggy aren't paying much attention to the signs. Snow in Chico has always been rare, so a spin around town was just too tempting. (Courtesy of John Nopel.)

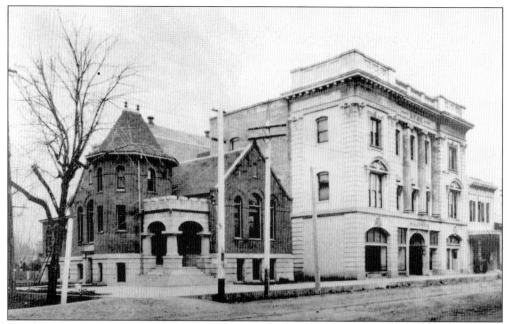

Construction of Chico's Romanesque Carnegie Library, on the corner of West Second and Salem Streets, was finished in 1904. Next to it is the Elks Building, completed in 1905, with the Majestic Theater on the ground floor. The structure was built by the Chico Elks Lodge, which occupied the upper two floors. Joining the Majestic, a popular place for silent films and vaudeville shows, were two spaces for retail or professional businesses. (Courtesy of John Nopel.)

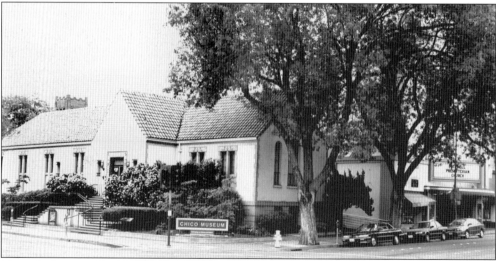

Chico had two public libraries for a while, but the Chico Branch of the Butte County Library prevailed after it opened on February 22, 1983. The aging city building, constructed from one of hundreds of grants from steel magnate Andrew Carnegie to build public libraries, had no purpose until the Chico Museum came along. The museum association renovated the facility and opened it in 1986. It features rotating exhibits on regional history and culture. The Elks Building, after housing the Majestic Theater, leased space to the American and National Theaters before fire gutted the place in 1948. It reopened as the El Rey later that year. This photograph was taken in 2005.

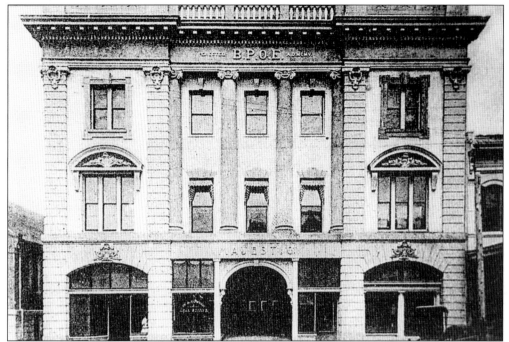

Once much more ornate than it is today, the Chico Elks Lodge was constructed in 1905 on West Second Street, between Salem Street and Broadway. The Elks used the upper two floors for their fraternal activities, while the ground floor served as the Majestic Theater, a popular moviehouse and vaudeville stage for many years. The theater became the American, then the National, and after a 1948 fire gutted the building, it became the El Rey. (Courtesy of John Nopel.)

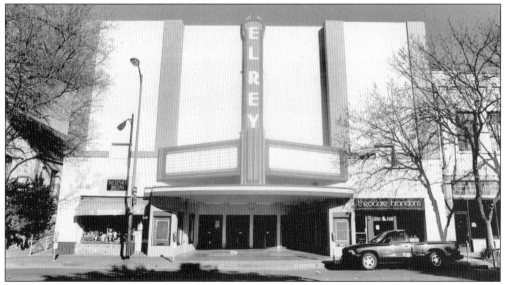

The El Rey, despite being Chico's last downtown cinema, showed its last movie March 3, 2005, after its owner, Nashville-based Regal Entertainment, decided to close it, citing a lack of profitability as the main cause. Local developer Eric Hart and San Jose investor Tom Overbeek announced plans to buy the building from Regal and convert it to office and retail space. The new name of the building? The Majestic, honoring its early heritage.

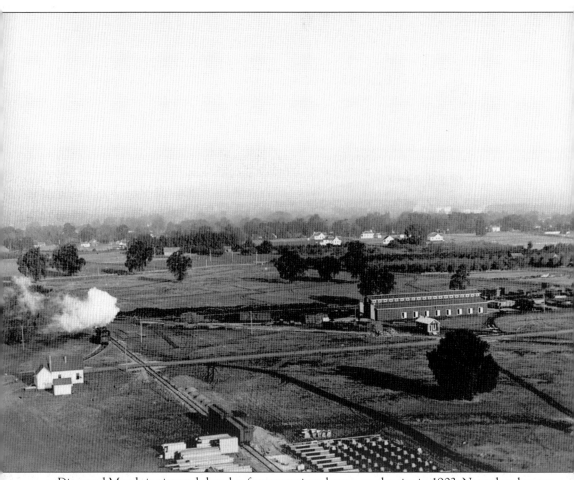

Diamond Match is pictured shortly after operations began on the site in 1903. Note the absence of buildings. They were constructed in 1904–1905 as the plant began to boom. Now a part of the Barber Yard project to revitalize the area for housing and commerce, Diamond Match's grounds are forlorn and deserted. The company operated at the site until 1984, when it was purchased by Louisiana Pacific, the facility closing for good in 1989. All but five of the buildings on the site were demolished. The city annexed the property in 1997, and a group called Barber Land, LLC bought it in 1999, with plans for housing, retail, and other commercial uses. Unfortunately, two of the oldest buildings on site, the apiary and the lumber warehouse, were destroyed by vandals who set fire to them in August and November of 2004, respectively. Teenagers were arrested as suspects in both fires. The engineering department still stands despite sustaining considerable damage. (Courtesy of John Nopel.)

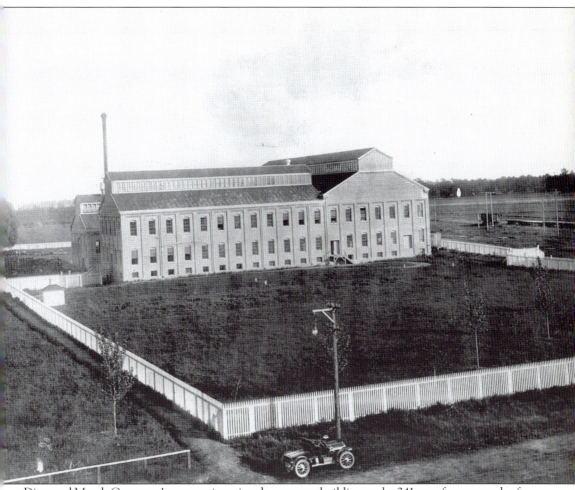

Diamond Match Company's new engineering department building at the 241-acre factory south of Chico, in what was called the Barber neighborhood, is pictured in 1904, a year after the company commenced operations on the site. Barber had its own railroad station, despite being only about a mile south of the Chico train stop, indicating the area's importance. The neighborhood was home to hundreds of Diamond workers, essentially creating a town within a town, though it wasn't annexed to Chico until the 1940s. Diamond had a logging and milling operation in Stirling City, some 35 miles away in the Sierra Nevada foothills, above Paradise and Magalia. Barber was named for the president of Diamond Match, Ohio Columbus Barber. (Courtesy of John Nopel.)

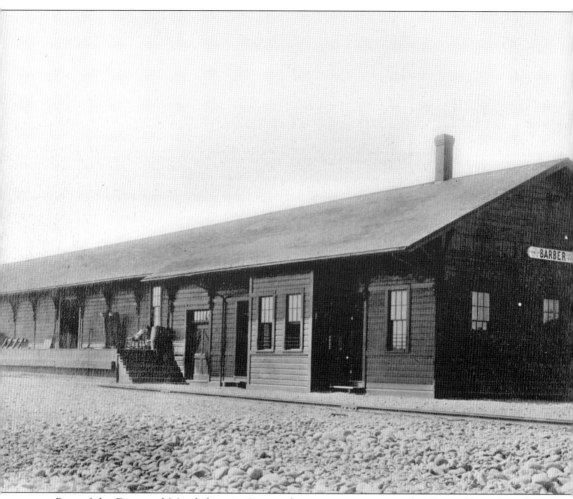

Part of the Diamond Match location's appeal was its proximity to the Central Pacific railway, and Barber, less than two miles from Chico's station, had its own well-furnished train depot. It served not only people traveling north and south along the Sacramento Valley, but those heading to Stirling City, Diamond's largest source of fresh timber, some 35 miles to the east in the Sierra Nevada. Paradise and Magalia also benefited from this rail connection. (Courtesy of John Nopel.)

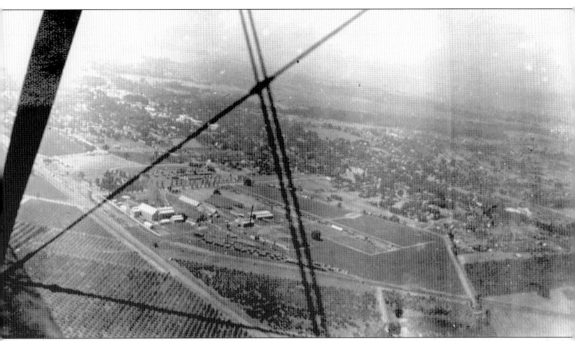
This aerial view shows Diamond Match in 1918. By that time, the plant was in full operation. The rail line that starts in the lower right corner and disappears into the edge of the photograph began at Barber, running through Paradise and Magalia, and finishing in Stirling City. (Courtesy of John Nopel.)

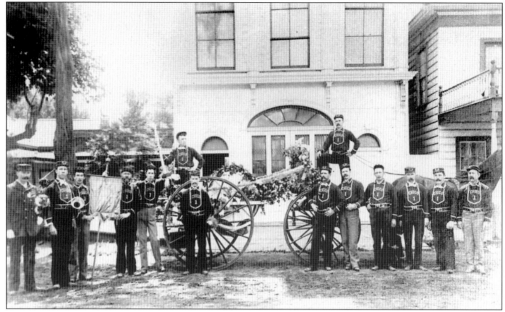

Members of Chico Fire Department's Engine Company No. 1 pose outside their station on East Second Street between Main and Wall Streets in the late 1880s. This company frequently competed with Chico Engine Company No. 2 and the Deluge Fire Company, another municipal firefighting unit, in public exhibitions to prove which group was most adept at snuffing out fires. Engine Company No. 1 moved its operations adjacent to city hall in the 1920s, then to its present location at the corner of West Ninth and Salem Streets in 1962. The company was established April 5, 1872, after Chico had been incorporated as a city on January 8. The building was constructed through a bond sale in 1874. (Courtesy of John Nopel.)

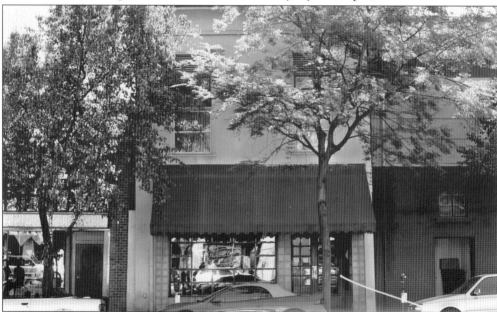

The building, which retains some of its original character, minus the tower, is now home to Panama Bar and Grill. The upstairs of the old building is used for office space.

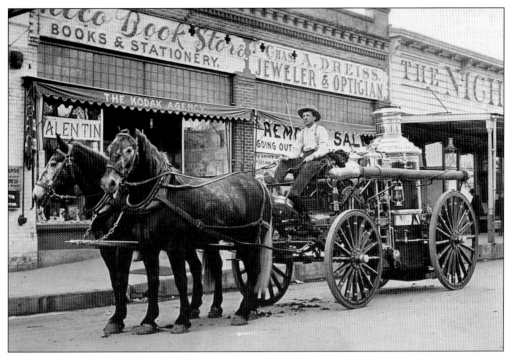

Chico's shiny, new steam engine is pictured on Broadway in 1914, on display for citizens. Chico Book and Stationery as well as Nichols Hardware, two of downtown's well-established firms, are visible in the background. (Courtesy of Butte County Historical Society.)

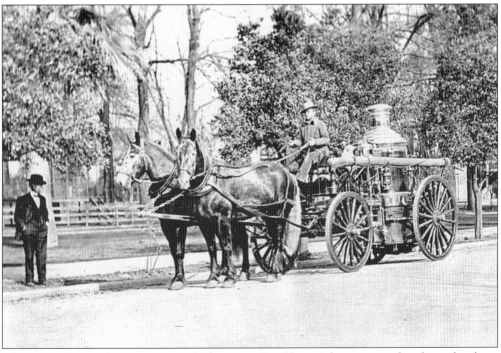

Chico's 1915 steam fire engine is parked next to City Plaza. Advances in vehicular technology, along with street paving, made horse-drawn equipment obsolete. (Courtesy of John Nopel.)

The Sypher residence at West Sixth Street and Normal Avenue is pictured about 1905. J. Maxwell Sypher was a musician of note who gave lessons in voice as well as many instruments. He organized the Majestic Orchestra in 1910 and led the 10-piece ensemble, the first such group in Northern California. Sarah Bernhardt visited Chico in 1913 and performed with the orchestra, describing Chico's group as the best she had ever seen for a town of its size. Sypher was also music director at Chico's three theaters. (Courtesy of John Nopel.)

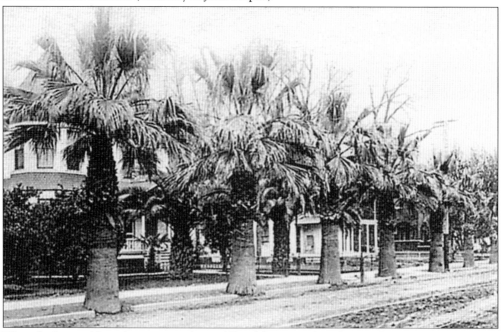

Though obscured by palm trees, in the middle of this row of residences along West Fifth Street, between Hazel and Ivy Streets, is the home of Albert G. Eames, a local businessman who was a Chico city councilman when it was built. The structure still stands as the Theta Chi, a Chico State University fraternity. This photograph was taken around 1905. (Courtesy of John Nopel.)

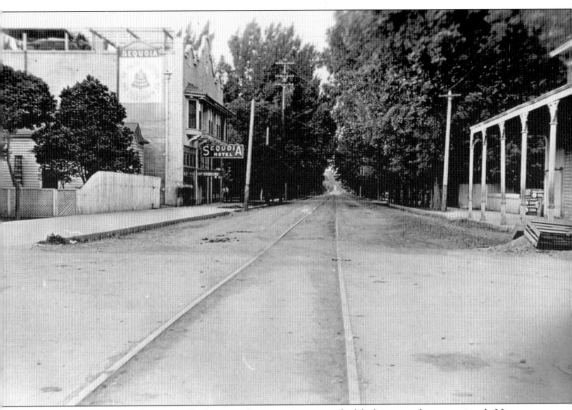

This extremely rare photograph shows a feature most people likely never knew existed. Here, looking west on West Fifth Street from Broadway, a rail line heads out toward the Sacramento River some six miles away. The line carried streetcars taking workers from Chico to the new sugar-beet processing plant that opened in Hamilton City in 1907. When the streetcar reached the river, passengers crossed the water in a boat, a trip made hazardous by high water during flood times. A cable was attached to the boat to make it a bit safer. On the opposite shore was another streetcar that took workers to the plant in Hamilton City. At left in this photograph is the Sequoia Hotel, which opened in 1910. (Courtesy of John Nopel.)

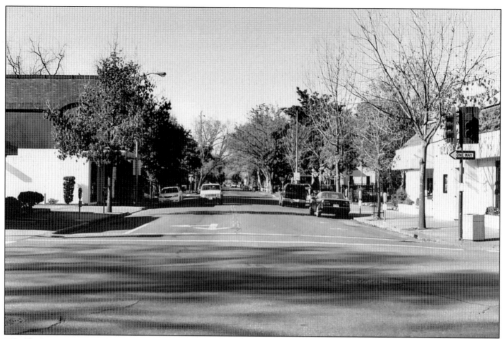

North State National Bank purchased the decrepit Sequoia Hotel in 1980, renovated it and opened for business in 1982. Tri Counties Bank acquired North State and has occupied the building since 2002. At right is Taco Bell, a fast-food mainstay on the corner since 1965. With the construction of the Gianella Bridge over the Sacramento River in the 1920s, and Nord Avenue's eventual designation as Highway 32, the streetcar line out Fifth Street became obsolete.

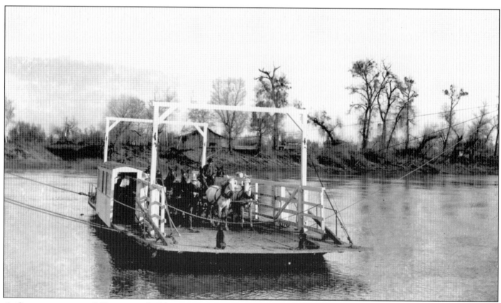

A ferry connected Butte and Glenn Counties over the Sacramento River around 1910. It began on the Butte side at the end of the rail line beginning in downtown Chico, carrying workers to Hamilton City's new sugar-beet processing plants. High winter river flows could make the trip arduous, if even possible. (Courtesy of Butte County Historical Society.)

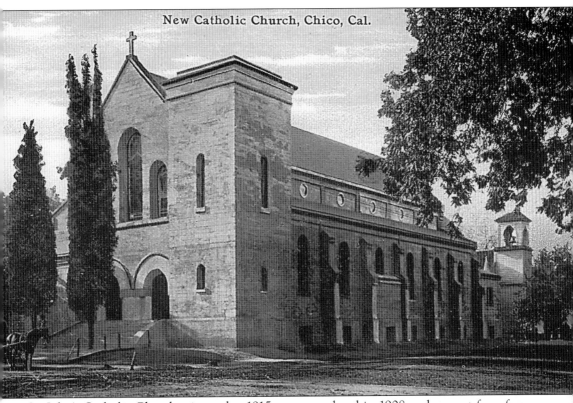

St. John's Catholic Church, pictured c. 1915, was completed in 1908 and, except for a few minor changes, looks about the same today. It also houses Notre Dame School, a parochial school for students in kindergarten through the eighth grade. (Courtesy of Butte County Historical Society.)

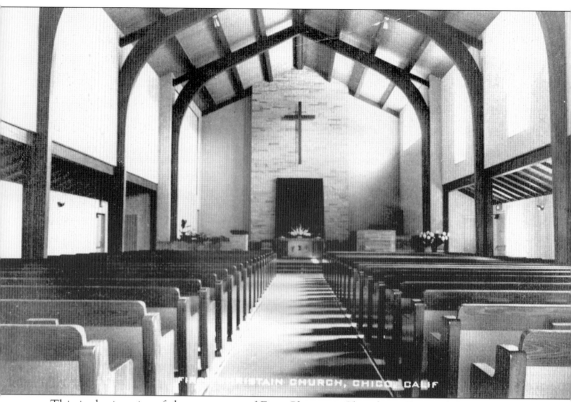
This is the interior of the sanctuary of First Christian Church on East Washington Avenue, shortly after its completion in 1956.

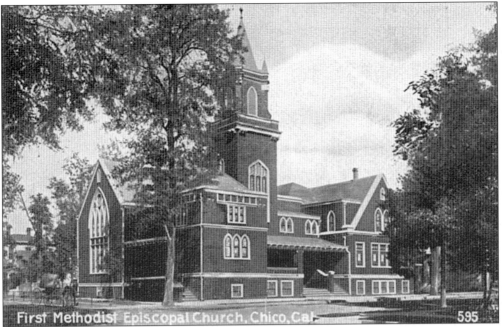

This 1904 postcard shows the First Methodist Episcopal Church in downtown Chico. (Courtesy of John Nopel.)

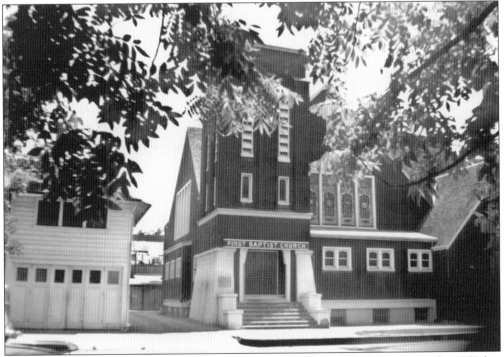

The First Baptist Church on Salem Street between Fifth and Sixth Streets is pictured c. 1950, but its site is now a parking lot for Tri Counties Bank's downtown branch. The congregation moved to its present site on Palmetto Avenue in the 1960s.

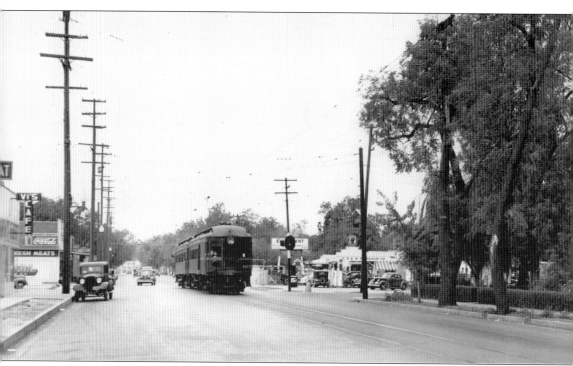

In this view looking north on Park Avenue in the 1930s, a Sacramento Northern train heads south on a run to Sacramento. Park Avenue began to take shape as a major thoroughfare before World War I as the Diamond Match Company established itself in the area. Park later became part of U.S. Highway 99 and today serves as an adjunct to the downtown business district. City of Chico planners are trying to turn Park Avenue, now dotted with used-car lots, small retail and light industrial businesses, into a redevelopment zone that could offer buildings with retail and residential space, and a more pedestrian-friendly atmosphere. (Courtesy of Butte County Historical Society.)

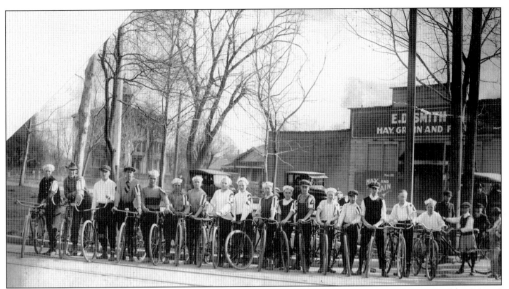

It's George Washington's Birthday, 1920, and several young men are gathered at Ninth and Main Streets for the start of a bicycle race through downtown. (Courtesy of Butte County Historical Society.)

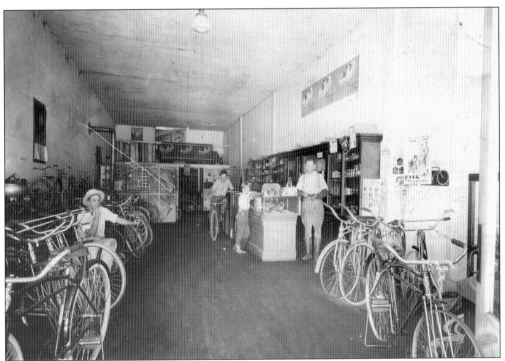

Pullins Cyclery, shown in July 1922, was opened by Charles Pullins in 1918. It occupied the corner shop at Ninth and Main Streets before moving to Eighth and Main Streets, on the same block, in the 1960s. It still sells bicycles and related supplies today. (Courtesy of Butte County Historical Society.)

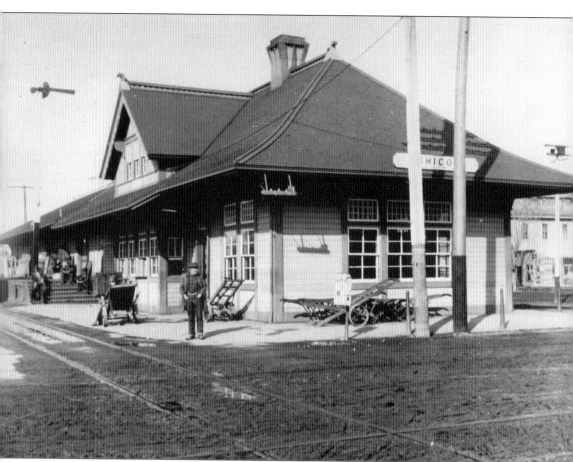

Passengers wait for the next train to arrive at Chico's depot in 1912, built for the Central Pacific Railroad, which became the Southern Pacific and finally the Union Pacific. At right is the Western Hotel on Orange Street, a simple hostelry catering mostly to those traveling by rail. Chico is unusual among towns its size as the railroad doesn't run very close to the central business district; in fact, it's seven blocks west of Broadway. (Courtesy of Butte County Historical Society.)

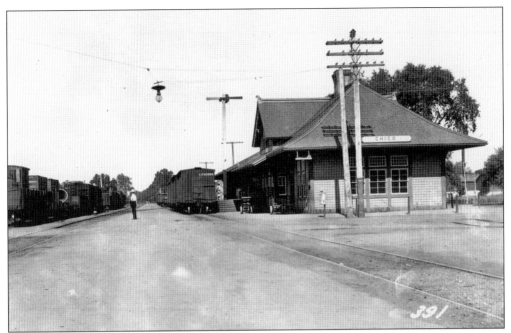

Chico's train depot, at West Fifth and Orange Streets, is pictured here in a view looking north. Orange was the last in the five-street sequence John Bidwell used when he laid out the town, taking the first letter of each to spell C-H-I-C-O. The others are Chestnut, Hazel, Ivy, and Cherry. (Courtesy of John Nopel.)

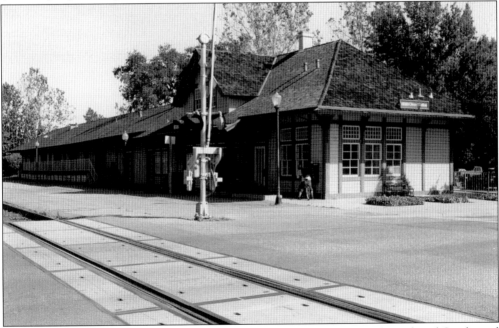

The train depot now has quite a mix of uses, serving not only as the town's Amtrak and Greyhound terminal, but also as the Chico Art Center in the old freight section. Members of the art center also purchased a 1948 Pullman car in 2000 that they are refurbishing in an effort to turn it into a gift shop. The car sits in the parking lot in front of the depot.

This view of downtown Chico, taken from the upper floors of Chico State Normal School in about 1905, shows a rail spur off the main north-south Southern Pacific Line, serving the Sperry Flour Mill across from the Bidwell Mansion. It appears along West First Street at the bottom of the photograph. (Courtesy of John Nopel.)

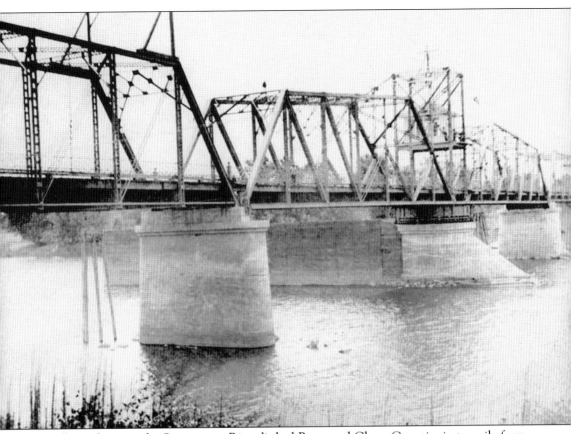
Gianella Bridge over the Sacramento River linked Butte and Glenn Counties just a mile from Hamilton City. The bridge served Highway 32 traffic crossing the river, and was replaced by a wider concrete span in 1990. (Courtesy of John Nopel.)

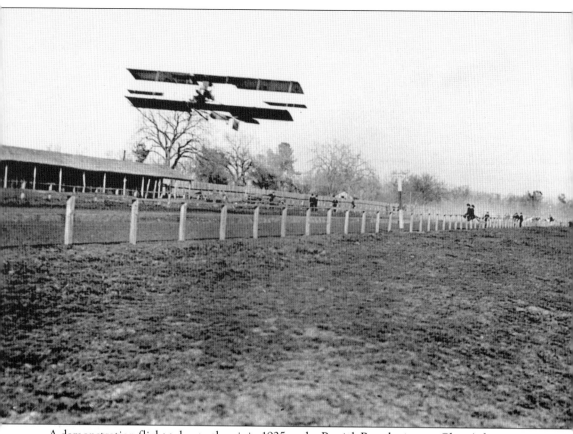

A demonstration flight takes to the air in 1925 at the Patrick Ranch airport, Chico's first airport, located just off the Midway, south of Chico. The strip still exists, though the Chico Airport was established in its current location off Cohasset Road in 1935. (Courtesy of John Nopel.)

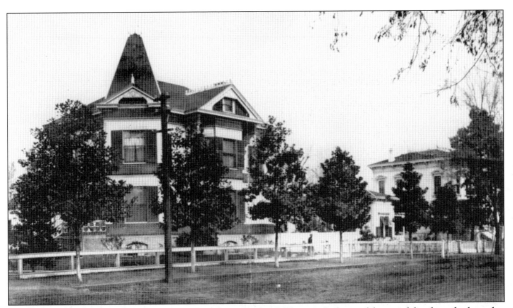

Homes along West Fifth Street once made up one of Chico's fashionable neighborhoods, but the area is now dominated by student housing. Fifth Street is the route savvy motorists take if they want to reach southbound Interstate 5 in the shortest way possible. It becomes Chico River Road, then Ord Ferry Road, on the way to Highway 45 in Glenn County. (Courtesy of John Nopel.)

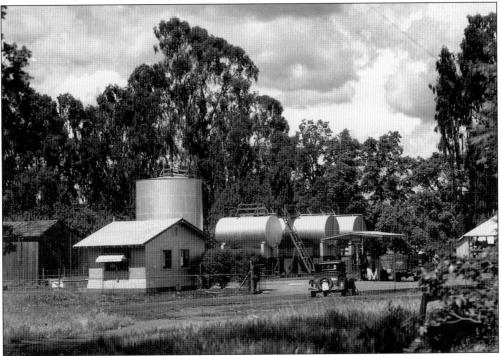

Pictured in the 1930s, this early "tank farm" off the Midway, south of Chico, was used for storing gasoline for wholesale distribution. The site, also bordered by Hegan Lane, expanded over the years and now has pipeline connections to Sacramento and the San Francisco Bay Area, serving distributors in those areas. (Courtesy of Butte County Historical Society.)

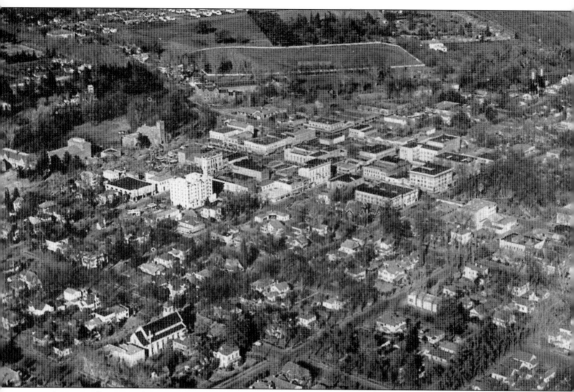

An aerial view of downtown Chico in the late 1940s shows, to the left of center, the Hotel Oaks, the six-story white building, while Memorial Field is at the top. It would become the site for Chico Junior High School in 1953. The Chico Cemetery is just beyond. (Courtesy of Butte County Historical Society.)

Seven
YOU CAN'T GET THERE FROM HERE

The Sierra Lumber Flume, pictured in 1898, was a means of floating freshly cut timber down from the Sierra Nevada foothills to the mills in Chico. The flume's terminus in the valley was on Chico's Flume Street, which today shows absolutely no evidence of the flume's existence.

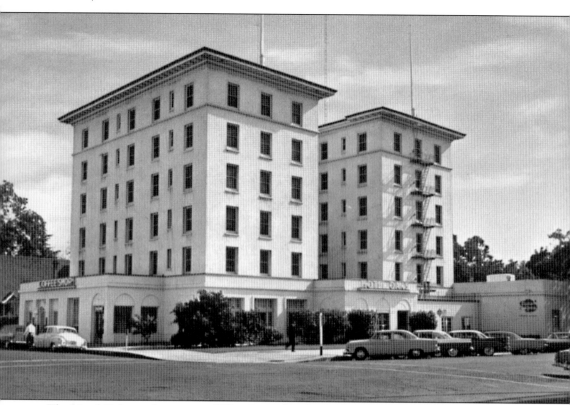

The Hotel Oaks, at the corner of West Second and Salem Streets, was completed in 1919. It was widely regarded as Chico's most luxurious hotel, featuring a grand ballroom, two restaurants, and a lounge. Many civic organizations used the ballroom for their meetings and functions. The hotel prospered for decades, but fell victim to the automotive age when the Highway 99 freeway was completed in 1965. The hotel itself closed in 1966, but the restaurants and lounge continued until 1969, when the facility closed for good. It was demolished shortly thereafter and is now a city parking lot. Across the street was the Oaks Garage, a full-service automotive facility, which closed in 1973 and was also demolished. (Courtesy of Butte County Historical Society.)

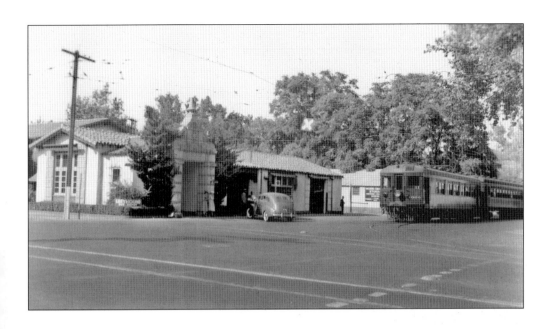

Above, Sacramento Northern Railway's No. 11 leaves the Chico Passenger Station at First and Main Streets for San Francisco on August 4, 1940. Below, the Sacramento Northern train "Comet" heads south on Main Street, also bound for San Francisco, the afternoon of October 20, 1940. (Courtesy of Butte County Historical Society.)

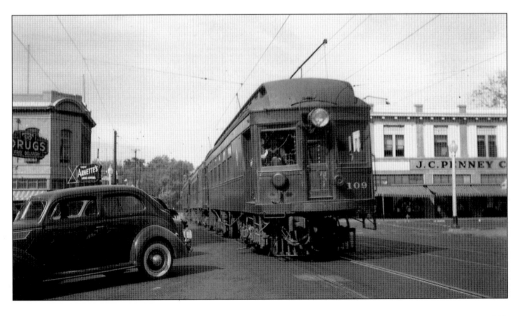

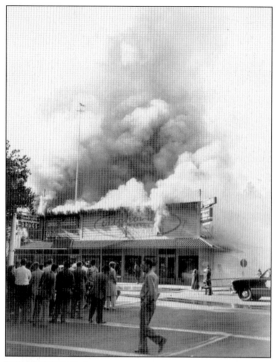

Nichols Hardware burned beyond repair in 1950. Opened in 1885, the company provided not only the ordinary hardware and related goods, but served as a contractor for numerous building projects in Chico, including the Presbyterian Church at First and Broadway. Nichols Hardware had suffered fires before, but the 1950 blaze damaged the building badly because of its wood construction and the fact that the floor was saturated from oils and solvents spilled over the years. Seen below is the scene as captured from the roof of the adjacent La Grande Hotel. Bank of America now occupies the site. At the top of the photograph, across West Fourth Street, are the Hotel Diamond (left) and the Morehead Building. (Courtesy of John Nopel.)

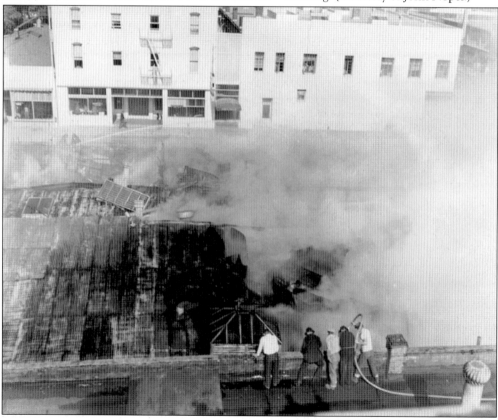

The Morehead home in west Chico was built in 1877 and is shown above near the turn of the 20th century. James J. Morehead was a prominent cattleman in early Chico, arriving in 1852 from Virginia (an area that would become West Virginia). Morehead served as superintendent of the Parrott Ranch, an early Mexican land grant, but purchased Rancho de Farwell in 1870 and ultimately expanded it to 1,154 acres. He also constructed and owned the Morehead Building at the corner of Broadway and West Fourth Street, which still exists. He died on February 5, 1885, at age 56. Below, the home is shown from the front. (Top courtesy of Butte County Historical Society; bottom courtesy John Nopel.)

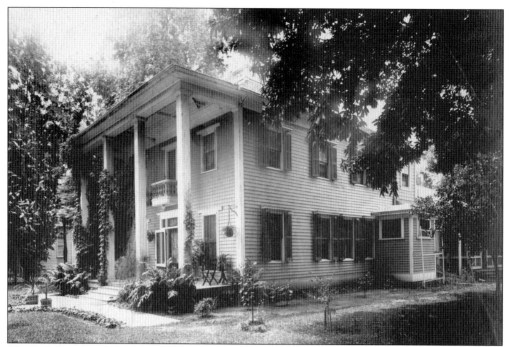

The Park Henshaw home on West Fourth Street is pictured around 1910. Henshaw was a prominent Chico attorney and civic leader, active in virtually every fraternal and service organization. The Henshaw family also had considerable land holdings, including the area approximately three miles north of downtown, where Henshaw Avenue is now located. (Courtesy of Butte County Historical Society.)

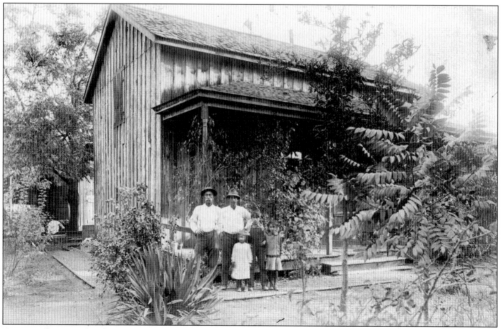

An unidentified Chico family poses in front of their simple, board and batten house west of downtown, about 1890. (Courtesy of Butte County Historical Society.)

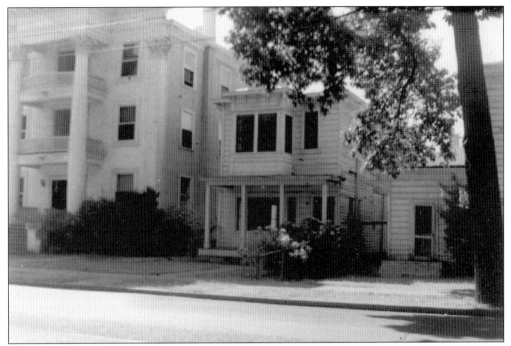

This 1959 photograph shows the Theil home (center) on the south side of West First Street between Normal and Hazel, across from Chico State College. At left is an apartment complex, which catered mostly to college students. The buildings, where the Chico State University Performing Arts Center is located, were razed in the mid-1960s as the college began to expand. (Courtesy of Butte County Historical Society.)

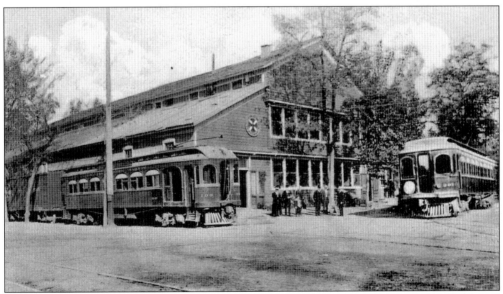

The Northern Electric Train Depot at the corner of First and Main Streets was strategically located at the north end of Chico's commercial district. Until the 1930s, the district was bounded on the north by Big Chico Creek. (Courtesy of John Nopel.)

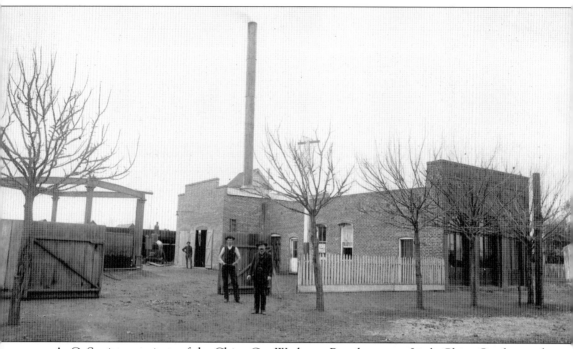

A. C. Swain, proprietor of the Chico Gas Works on Broadway near Little Chico Creek, stands with his coat on in the 1890s. The man just behind him is unidentified. Swain's operation was Chico's first large-scale gas works, following several that provided, at best, sporadic and unreliable gas supplies. The first, in 1862, used wooden pipes under the streets to carry gas. By the time this photograph was taken, electricity was becoming economically viable for home use, though gas would remain a crucial utility. (Courtesy of Butte County Historical Society.)

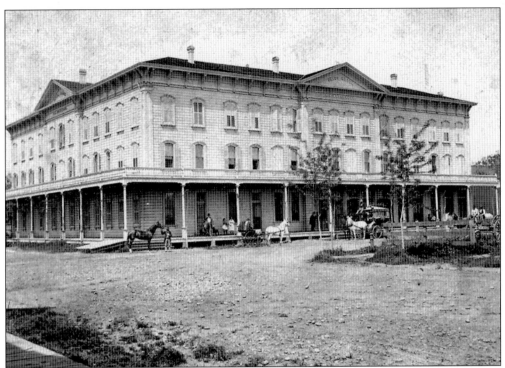

Ira Weatherbee's Chico Hotel, along West First Street between Salem Street and Broadway, was finished in 1878 and was Chico's premier hotel until it burned in 1890. It is now the site of a parking lot, a sandwich shop, and a small collection of stores. (Courtesy of Butte County Historical Society.)

Around 1900, this residence was at the southwestern corner of West First and Salem Streets. The site is now occupied by Chico State University's Alva P. Taylor Hall, completed in 1970. In the background at left is the Lusk Building, finished in 1885, that served as C. F. Lusk's law offices, his residence (upstairs), and later as the meeting hall for the Native Daughters of the Golden West. It is now home to Madison Bear Garden saloon and restaurant. (Courtesy of John Nopel.)

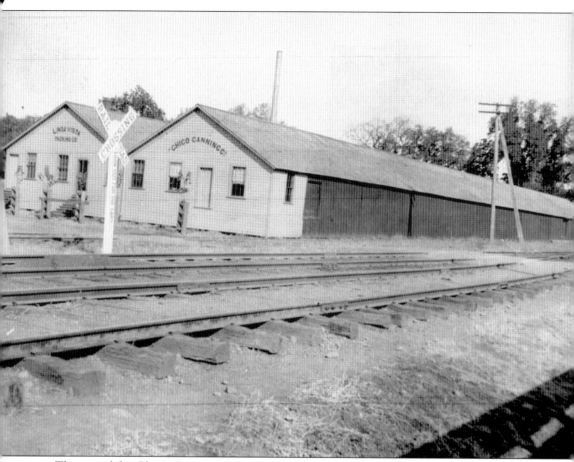

The site of the Chico Canning Company, next to the railroad tracks at West First and Cedar Streets, is now occupied by Chico State University's maintenance facility. Directly across the tracks was a similar business, the California Packing Company. (Courtesy of John Nopel.)

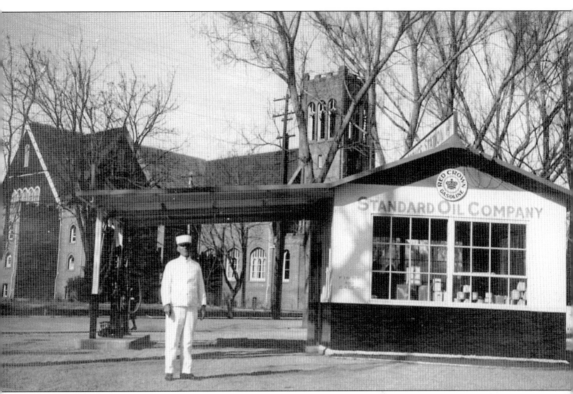

Standard Oil's service station at the corner of West First and Salem Streets is pictured here in 1938, when First Street also served as state Highway 32. In the background is the Bidwell Memorial Presbyterian Church. (Courtesy of John Nopel.)

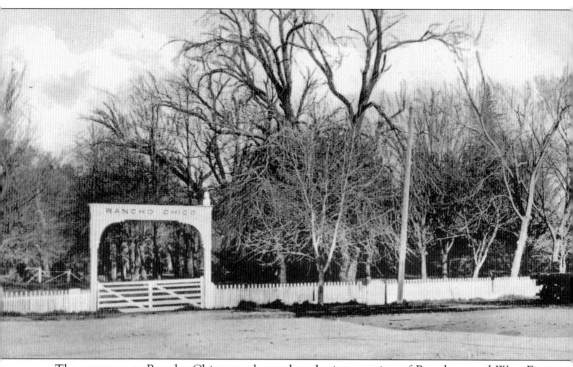

The entrance to Rancho Chico was located at the intersection of Broadway and West First Street. The area pictured here became Children's Playground after Annie Bidwell bequeathed the grounds to the city in 1911. (Courtesy of John Nopel.)

This mid-1920s photograph shows the Triangle Service Station, across from Children's Playground. Gas stations occupied the three-sided parcel bordered by First and Main Streets and the curved road known as Shasta Way until it was purchased by the City of Chico for use as a small park and bus stop. All that remains of the final service station on the site are the restrooms, now available for public use. (Courtesy of John Nopel.)

The Northern Electric Railway, which later became the Sacramento Northern, kept its cars in these barns along Park Avenue, just south of what is today East Twentieth Street. It also operated the hotel at left, which catered to weary travelers or outgoing ones who just wanted to save a few minutes by already being a mile or so south of downtown Chico. Trains in this area were important because they served Diamond Match Company workers living in the Barber, Oakdale, and Chapmantown neighborhoods. This view is from approximately 1920. (Courtesy of John Nopel.)

The earlier Northern Electric Hotel along Park Avenue, just south of downtown, is pictured shortly after the line was established in 1907. (Courtesy of Butte County Historical Society.)

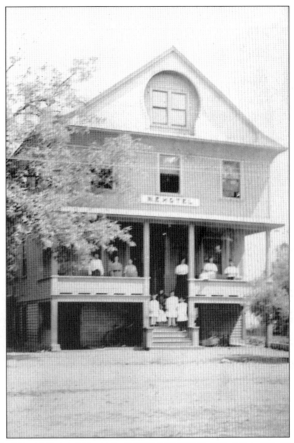

On the site now is a building with quite a varied background. Built in 1959 as the Gala Lanes bowling alley, the facility has since been home to Pat 'n' Larry's Steakhouse, owned by Larry Juanarena, as well as an auto parts store. Pat 'n' Larry's closed in 2001, and in its place is New World Buffet, featuring an Asian smorgasbord. This 2005 view shows the lot where the hotel and rail operations once stood. The site is now a parking lot and PG&E substation. The restaurant building is at extreme left.

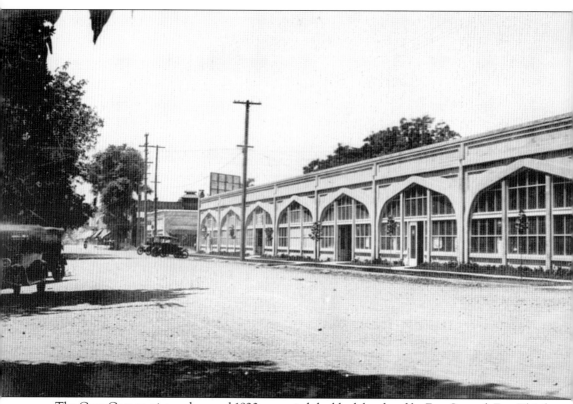

The Gage Garage, pictured around 1920, occupied the block bordered by East Second, East Third, Wall, and Flume Streets. It serviced automobiles, trucks, and farm equipment. By the 1960s, it had become the Sierra Dodge dealership, but when Chuck Patterson's Sierra Dodge relocated to its present site on East Avenue, the block was leveled to provide much-needed parking for downtown merchants and customers. The parking hasn't proven to be adequate, however. City officials are now considering a multistory parking structure that could provide several hundred spaces. (Courtesy of John Nopel.)

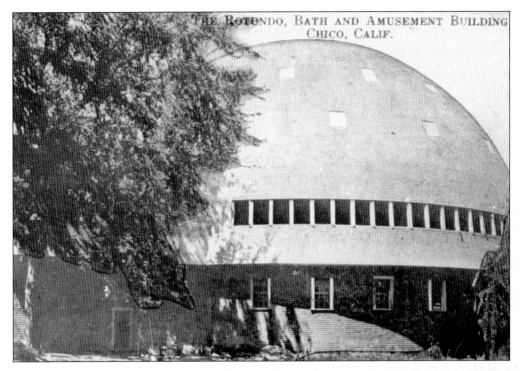

The Rotunda, a large entertainment center, was located along East First Street next to Big Chico Creek. Completed in 1911, the facility offered indoor swimming pools, skating, dancing, and meeting rooms. It was demolished in the early 1960s to make way for retail buildings and two city parking lots. (Courtesy of John Nopel.)

The Daniel Bidwell home was built along Sandy Gulch, now Lindo Channel, in north Chico. Daniel was John Bidwell's cousin who came to California in the 1850s to seek his fortune, which he found, allowing him to buy considerable acreage and later construct this stately Italiante home. It fell into neglect, however, and was demolished in the 1940s. (Courtesy of Butte County Historical Society.)

Pictured c. 1940 is the home on Entler Ranch, about three miles south of Chico. It was constructed in 1853 by Washington Henshaw, upon whose death it became the Entler Ranch, when Henshaw's daughter Susan Cynthia Henshaw married Joseph Franklin Entler. Their son Clarence S. Entler inherited the home and 200 acres upon Joseph's death in 1929. Five generations lived in the home. Entler Avenue, once a narrow country lane, now serves as a minor link between Highway 99 and the Midway. (Courtesy of Butte County Historical Society.)